PERSPECTIVE
MADE EASY

PERSPECTIVE MADE EASY

Ernest R. Norling

DOVER PUBLICATIONS
Garden City, New York

Bibliographical Note

This Dover edition, first published in 1999, is an unabridged republica-
tion of the work originally published by The Macmillan Company,
New York, in 1939.

Library of Congress Cataloging-in-Publication Data

Norling, Ernest R. (Ernest Ralph), b. 1892.
 Perspective made easy / Ernest R. Norling.
 p. cm.
 Originally published: New York : Macmillan, 1939.
 ISBN-13: 978-0-486-40473-8
 ISBN-10: 0-486-40473-0
 1. Perspective. 2. Drawing—Technique. I. Title.
NC750.N717 1999
742—dc21 99–10310
 CIP

Manufactured in the United States of America
40473029 2023
www.doverpublications.com

To

Professor Benjamin Harrison Brown

who has presented a complex Universe

in simple terms

FOREWORD

Perspective is easy; yet surprisingly few artists are familiar with the simple laws that make it so. It is the purpose of this book to make these laws clear.

One of the things that have simplified perspective for us is our way of building things. We live in a world of square corners; our streets, buildings, furniture, all are designed with a square. We find it convenient to be able to fit any of the corners of a table into any of the corners of the room; hence we build that way. This fact has made perspective drawing quite simple. When we have learned to draw the humble brick we have learned practical perspective.

This book explains perspective step by step, depending on illustrations to carry the sequence. Some steps are repeated, but deliberately so, to emphasize their importance. A great deal of stress is placed on "the eye-level." A bird's-eye view and a worm's-eye view of the world are quite different. A six-foot man in a crowd sees hats and hair, faces and shoulders. A four-foot child beside him sees hands, gloves, purses, and coat-tails. They are both seeing the same people at the same

time. How different are their two visual worlds! Our height above the ground is an important factor when we sketch the world about us. The eye-level is really the key to perspective drawing.

The knowledge of perspective should be used as a guide to drawing and not as a device to harden into stiff mechanics what might have been a beautiful loosely handled sketch. We build a strong scaffolding for the construction of our bridge; later we discard the scaffolding and keep only the graceful span.

TABLE OF CONTENTS

xi

PERSPECTIVE
MADE EASY

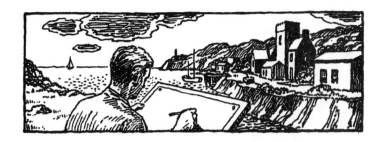

PERSPECTIVE

The artist's business is to be able to draw an object so that it will look solid and not flat like the surface of the paper on which it is drawn. In so doing the artist employs a method that we call perspective.

A brick drawn without the use of perspective.
This is called a plan.

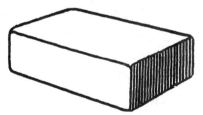

A brick drawn with the use of perspective.
This is called a drawing in perspective.

Perspective is used not only to make the object appear to have dimensions but also to cause it to appear close up or in the distance or to suggest a feeling of space.

3

THE HORIZON

Let us follow the railroad tracks out on the plain where there is level land in all directions as far as we can see. All around us we can see the sky meeting the distant plain in a long even line. This is called the *horizon*.

The ideal example of the horizon is seen when viewed across a large body of water where no distant shore is seen. At sea the horizon is one continuous line.

We may consider the horizon as continuous. This is true though the view may be obstructed by an object: a hand, a building, or a mountain. The horizon is still there though we go into the building and close the door. If objects became transparent the horizon could always be seen. This is illustrated on the opposite page.

4

THE VANISHING POINT

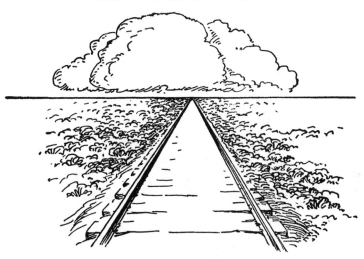

Now we stand between the two shiny rails and look along the track. These rails go on and on across the level plain until they reach the horizon where they are lost from sight in the distance.

We call the place where they disappear the *vanishing point.*

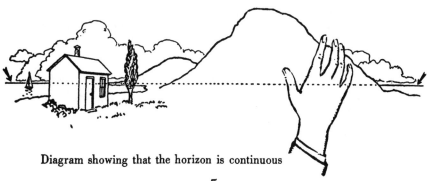

Diagram showing that the horizon is continuous

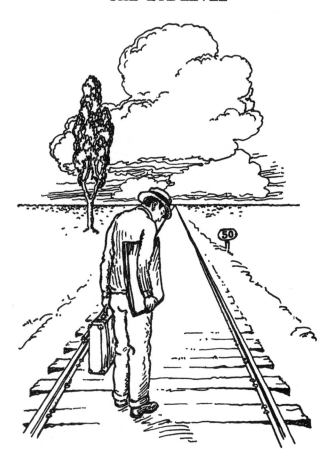

Now look down at your feet. There you see the track. Raise your eyes and look fifty feet beyond. You still see the track although you are not looking directly down upon it.

6

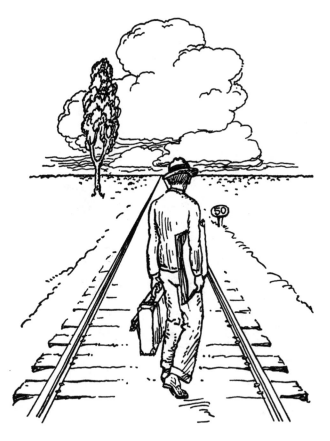

Then look straight ahead. You see the track as it climbs to a height level with your eyes and disappears at the horizon in the distance. This height can be called the *eye-level.*

Here the horizon and the eye-level become one and the same thing.

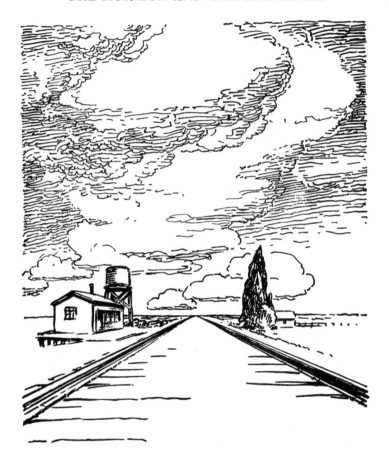

Now sit down on the track and look about. You will find that your eye-level has lowered. The distant horizon also appears lower in order to meet this change of eye-level.

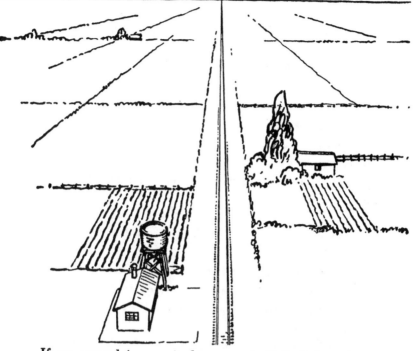

If we ascend in an airplane we shall find that the distant horizon rises with our height. It appears to remain at eye-level.

This accounts for the peculiar basin-like appearance of the earth when viewed from a great height.

We can now understand why the drawing of the corner of a room looks different when sketched from a low stool as compared with one sketched from the top of a stepladder.

The height of the eyes becomes a very important factor in freehand drawing.

9

REMEMBER

We use perspective in drawing a brick so that it appears as a solid object.

The horizon is that distant line where the earth and the sky seem to meet.

The vanishing point is the place on the horizon where the rails of the tracks appear to meet.

The horizon is the height of your eyes no matter where you are above the ground.

The eye-level is the height of your eyes no matter where you are.

PROBLEMS

Draw a brick, a box, a book. Do you know just why you draw it as you do?

If you are in level country or near the ocean look for the horizon. Experiment by looking from different heights: from the ground, from a window, from the top of a building. Must you ever look up or down to see it?

Locate vanishing points in things other than railroad tracks.

Make a sketch from the center of a level street with the sidewalks representing the two rails of the track.

STEP TWO

THE EYE-LEVEL
AND ITS RELATIONSHIP
TO PERSPECTIVE DRAWING

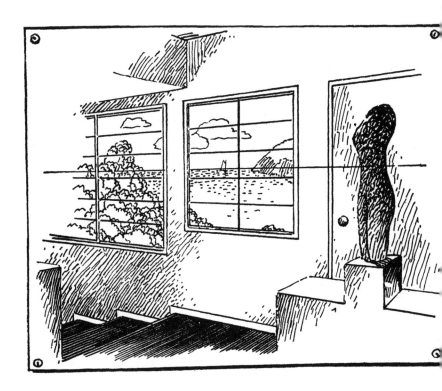

THE EYE-LEVEL IS ALWAYS REPRESENTED BY A STRAIGHT LINE

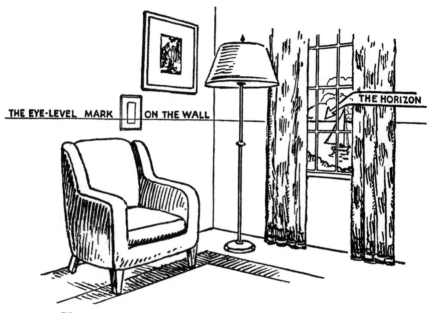

You are seated sketching the interior of your room. Someone makes a mark around the wall the same height from the floor as your eyes. This mark will appear as a straight line across your drawing. It is the eye-level.

Notice in the drawing that the visible horizon seen through the window is the same height as the eye-level mark on the wall.

"THE EYE-LEVEL IS LEVEL WITH THE EYE"

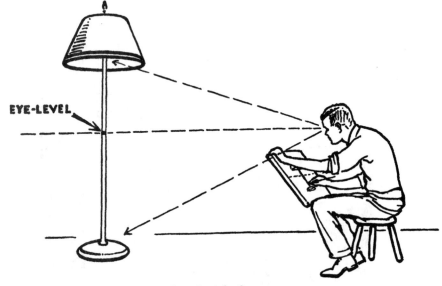

The eye-level is level with the eye.

You may smile at the simplicity of the above defini-
tion, yet it is a surprising fact that it is ignored in prac-
tice even by professional artists. Its importance, how-
ever, is immeasurable.

Let us look into it.

On the preceding page is the drawing of the room
corner; there are the pictures on the wall, the chair, the
lamp, the window, and the drapes.

Now let us consider the lamp.

We are seeing the underside of the lamp shade; in
other words we are looking from below *up* into the

shade. Now let us look at the base of the lamp; it rests on the floor and it is necessary to look *down* upon it. The shade is above the height of our eyes while the base is below. Somewhere between is the eye-level, a place that is exactly the same height from the floor as are our eyes.

We show this eye-level by means of a straight line across the drawing.

We find that we have control over this eye-level line. We can look under the table and see the underside. We accomplish this by lowering our eye-level. We stand on tiptoe or step up on a box to see over the heads of people in a crowd. We do this to raise the eye-level. New pictures are constantly being formed before our eyes by our various ways of raising and lowering the eye-level.

It is interesting to watch for the effects and changes in a landscape when viewed from an automobile driven over a hilly road. Showmen have taken advantage of this fact and have built the Ferris Wheel, a mechanical means of swiftly raising and lowering the eye-level. The quick change of picture helps to intensify the experience.

We find that the objects we draw are in two classes: the ones that are above and the ones that are below the line that indicates the eye-level.

Now let us go into it further.

THE HIGH-WATER MARK

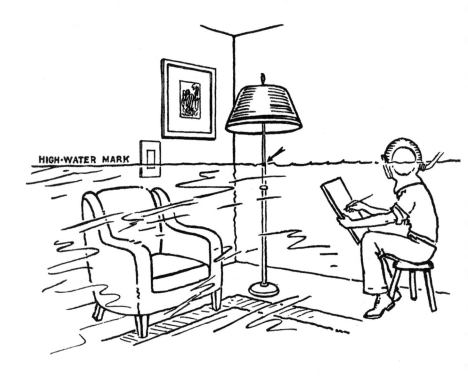

HIGH-WATER MARK

Imagine yourself wearing a diving helmet and seated in your room making a sketch of the interior. As you sit there the room is filled with water until it just reaches the height of your eyes. Now then; everything in the room that is under water is "Below the Eye-Level," everything that is not under water is "Above the Eye-Level." The "High-Water Mark" around the walls and

16

on everything else that it touches in the room is "The Eye-Level" itself. No matter in what direction you look this high-water mark appears to your eye as a straight level line across the objects of the room.

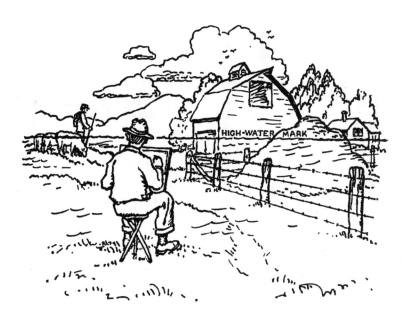

When you are sketching outdoors this "water level" explanation will still hold true. Fences, buildings, haystacks, people, all have a "High-Water Mark" which is the artist's eye-level.

If you are seated on the ground sketching, or if you are on a roof, the "High-Water Mark" explanation still holds true.

IMPORTANCE OF THE EYE-LEVEL

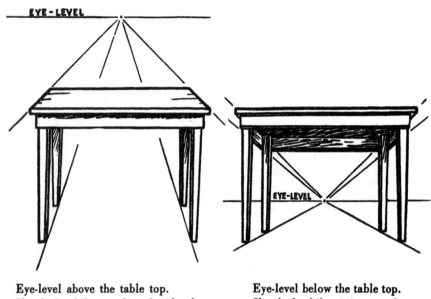

Eye-level above the table top. Sketched while standing beside the table.

Eye-level below the table top. Sketched while sitting on the floor.

It is easily seen that you would get two entirely different views of your table if you made a sketch while standing beside it, or if you sat on the rug and sketched the same table from that position.

The whole system of perspective drawing is based on the height of this eye-level; whether or not the eyes are above or below the thing that is being sketched.

18

Remember

The horizon is shown by a straight line across your drawing.

In a room you can create your own horizon. This is an eye-level mark around the wall.

We look up to see things above the eye-level and down to see things below the eye-level.

The eye-level is the high-water mark when the water is eye deep.

This line is the first thing we locate in making a perspective drawing.

The visible outdoor horizon is not to be confused with the Horizontal Line (*HL*) in mechanical perspective as explained in the last step of this book.

Problems

Draw a line on the blackboard the height of your eyes when you are standing. This will appear as a straight line, though it may be in the corner of the room where the line is on different walls.

Change to a seated position and take notice of the line in the corner of the room. Does it still appear as a straight line where it joins at the two walls? Stand on a chair and note the result.

Go outdoors and locate your eye-level mark on the various things you see around you. Imagine where the eye-level line would cut across these different things if you were making a drawing.

19

STEP THREE

PARALLEL LINES
AS WE SEE THEM

PARALLEL LINES
RELATED TO
ONE-POINT PERSPECTIVE

PARALLEL LINES AS WE SEE THEM

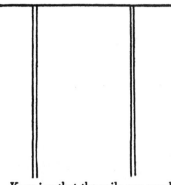

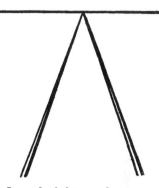

Knowing that the rails are parallel, why do we not draw them this way?

Instead of this way?

The two rails of the track are always the same distance apart.

When two or more lines always remain the same distance apart they are called parallel lines.

In a perspective drawing we do not actually draw these lines parallel. Why not?

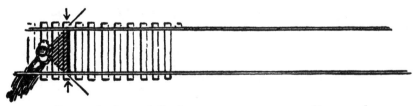

Let us look straight down on a person standing on the track and see what is happening.

When he looks down at the track at his feet his eyes must take in a wide area in order to see both rails.

He sees this width in front of him, as indicated by the
heavy black line.

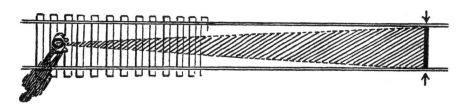

As he raises his eyes and looks fifty feet in front of him
he sees the same width of tracks but within a much nar-
rower area.

For this reason the track appears narrower as he
looks farther away.

The shaded portion on the sketch shows this area.

The portion he sees fifty feet away is shown by the
black line.

As he raises his eyes to the horizon the same width of track appears in so narrow an area that it looks like no width at all. This is the vanishing point.

Thus the nearer he looks, the wider appears the spread of the track, and the farther away he looks the narrower it appears until it becomes a point at his eye-level.

This wide or narrow area is perhaps better understood if we think of the person drawing these widths on a piece of glass held upright as shown on page 28.

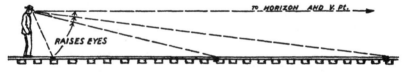

The above sketch shows how the man, in order to see farther along the track, must raise his eyes.

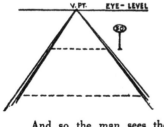
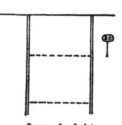

And so the man sees the track this way.

Instead of this way.

PARALLEL LINES AND ONE-POINT
PERSPECTIVE

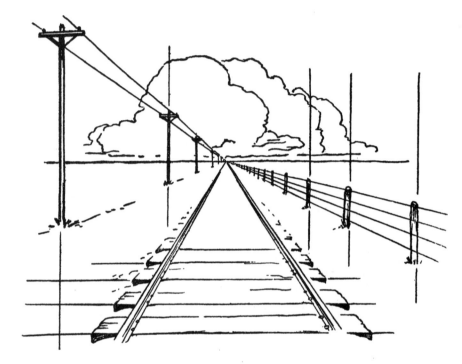

Parallel lines are two or more lines that extend in the same direction and remain the same distance apart.

The two opposite sides of a table are parallel, the boards of the floor, the rails of a track.

We know that the two parallel rails of the track appear to converge at a point in the distance. Now take notice of the fences and telegraph wires that follow the tracks; they also converge at this same point.

26

A group of parallel lines in a perspective drawing, if extended, meet at the same point.

There are two exceptions to this rule. These exceptions are shown in the drawing.

(1) When we face the vanishing point of a group of parallel lines (as in the picture) we have one-point perspective; in this case the left-and-right lines, like the ties of the track, are all parallel with the horizon. There is no vanishing point.

(2) Up and down (perpendicular) lines, like the telegraph poles and fence posts, are also drawn parallel but without a vanishing point. (Perpendicular lines are explained on page 45.)

The general rule for (1) and (2) is that parallel lines which are also parallel to the picture plane do not appear to converge at a point. The picture plane is explained on the next page.

A good example of parallel upright lines is a forest of tall straight trees. The trees farther back in the forest appear smaller, thus suggesting depth or distance.

THE PICTURE PLANE

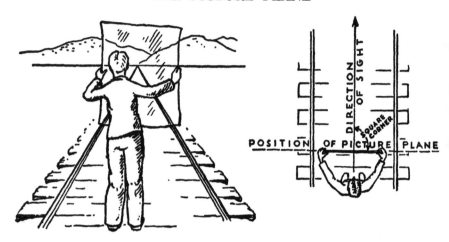

Hold a sheet of cellophane or glass upright before your eyes. You can see the object or scene before you through the transparent sheet. If you trace this scene as you see it on the sheet you will have a drawing in perspective. The transparent sheet can be thought of as a sheet of drawing paper or an artist's canvas. When held in this position it may be called the *picture plane*. We think of perspective drawings as made on this picture plane.

The picture plane stands upright (perpendicular) between the artist and the object he is drawing. Also, the picture plane is placed directly across (at right angles to) the line of direction in which the artist is looking. The diagram at the right explains this.

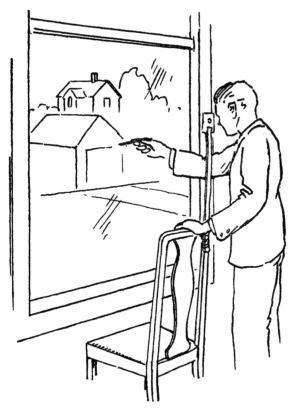

Drawing in perspective on the picture plane can be self-explained by standing in front of a window and with a china marking pencil tracing on the glass the outlines of the buildings as you see them.

A paper with a hole in it can be set at arm's length to help fix the point of view. Look through this hole and sketch as if the window were the sheet of paper. Simply trace on the glass the buildings and landscape as you see

29

them beyond the window. The result is a perspective drawing.

Suppose we remove the windowpane with this drawing and lay it on the table. On the table it looks like any other perspective drawing done on a piece of paper. How is it possible to make this drawing without first tracing it on an upright piece of glass? The following steps will explain how this can be done.

REMEMBER

The two rails of a track are parallel. These two parallel lines, when shown in a perspective drawing, come together at a point.

When two parallel lines meet at a point all other lines parallel to these two meet at the same point.

You lower your eyes to see your feet.

You raise your eyes to see objects on the ground at a distance.

The picture plane stands upright between the artist and the object he is drawing.

PROBLEMS

Draw the top view of a man standing at the end of a long narrow table. Show the difference in the area of his vision when looking at the width of the far end of the table compared with that of the near end.

Stand in the center of a straight level highway. Draw it as you see it—disappearing in the distance. Add a sidewalk parallel to it. Add two rows of telephone poles, a row on each side. Add a fence beside the walk.

Draw a railroad on the prairie sketched from the center of the track. Show a highway crossing it in the foreground.

STEP FOUR

THE THREE SETS
OF PARALLELS

LOCATING THE POINT
AND THE EYE-LEVEL

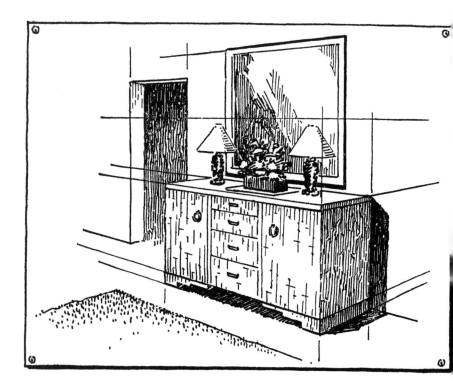

THE THREE SETS OF PARALLELS

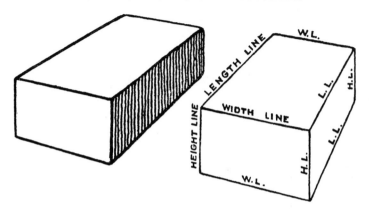

Here we have an ordinary brick.

It has six sides, but only three sides can be shown in the drawing.

The lines of the drawing indicate where two of these sides join.

If all sides of the brick were shown there would be twelve lines.

The four long lines which indicate the length of the brick are parallel lines.

The four lines of the width are parallel.

The four lines of height (or thickness) are parallel.

Now let us turn the brick so that we are looking straight along the length lines. The sketch on the next page shows it in this position.

We now have the end view of the brick.

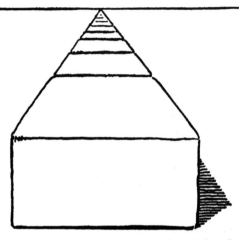

Remember how as a child you placed bricks end to end to make a railroad track? Try this.

You see that the facts discovered in regard to the railroad track on the plain now hold true for bricks; the line of the eye-level, vanishing point, and all.

Now let us remove all the bricks but one.

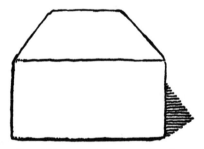

Here it stands. The vanishing point is gone from the drawing, so is the line of the eye-level.

34

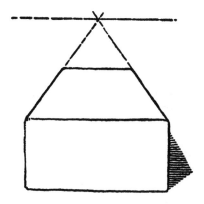

We can easily find the vanishing point and the eye-level by extending the lines that represent two parallel edges of the brick.

The vanishing point is where they meet.

A horizontal line drawn through this point gives us our eye-level.

Thus we can find the vanishing point and the eye-level by extending any two lines that represent converging parallel lines in a perspective drawing.

FINDING VANISHING POINTS AND THE LINE OF VISION

It is an interesting experiment to take cuts of photographs from magazines and then locate the vanishing points by extending the lines that are parallel. Where they cross is the vanishing point.

A straight line through the two vanishing points thus

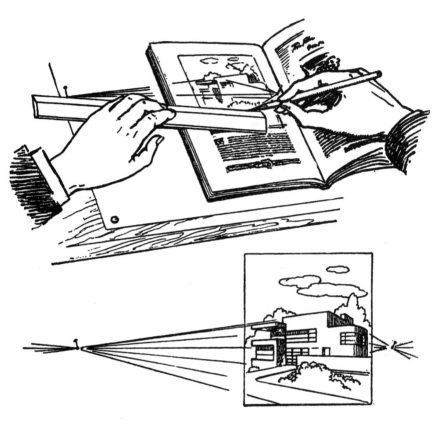

located shows on the photograph just how high the camera's eye was above the ground. This is the eye-level.

Any photograph of a building or a room can be used for this experiment. An easy method is to paste the photograph or clipping in the middle of a large piece of paper and then draw the lines right over the photo and paper.

Remember

A brick has six sides. Three of these can be shown in a perspective drawing. We draw a straight line to show where two sides join. Opposite edges are parallel lines.

A row of bricks placed end to end becomes a railroad track. All bricks but one can be removed, still we can find the eye-level and the vanishing point.

Problems

Draw an empty cigar box in perspective.

Show which of the sides are parallel. Which lines are parallel?

Draw the box, end-view in perspective.

Draw the box, side-view in perspective.

Find the eye-level and vanishing point of each of these drawings.

STEP FIVE

THE TWO VANISHING POINTS

POINTS

THE "HEIGHT" LINES

THE TWO VANISHING POINTS

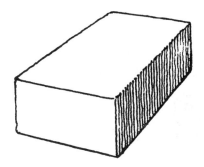

Place the brick flat on the table so that three of its sides can be seen.

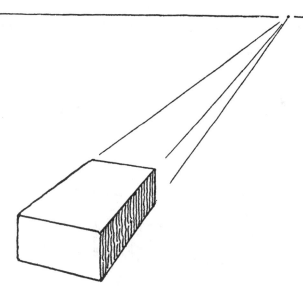

Now we have three lines which can be extended, thus locating the vanishing point and the eye-level.

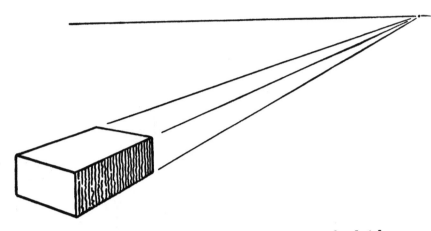

After locating the point and line turn the brick a trifle more.

This changes the vanishing point, but the eye-level is still the same.

EYE - LEVEL

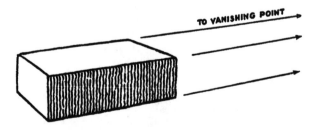

TO VANISHING POINT

The more we turn the brick the more the vanishing point changes, but always along the same eye-level.

42

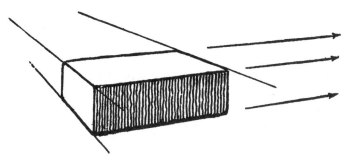

But wait!

Here is another set of parallel lines representing the width of the brick.

Let us extend these and see what happens.

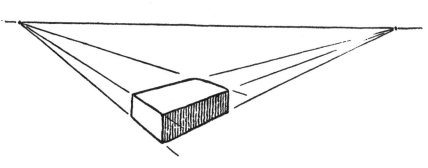

Here lies the brick just as before with its length lines extended to a vanishing point and the eye-level line passing horizontally through this point.

The width lines also meet at a point which lies on the

very same eye-level line as the point reached by the length line.

This must be as we see it because, when we glance at the three sides of the brick as it lies there on the level surface, our eye-level remains unchanged whether our attention is fixed on one group of parallels or on the other.

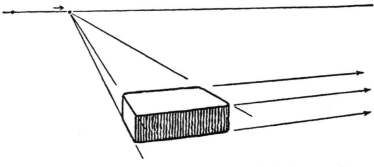

Turn the brick some more and we find that our first vanishing point moves away from the brick along the eye-level while the new point moves toward the brick.

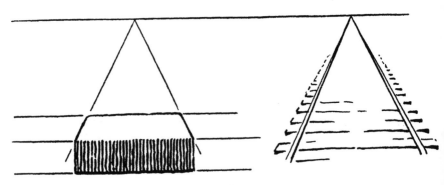

When the point comes directly above the brick we again have the railroad track with one set of receding parallel lines. The other set is parallel with the horizon. The latter can also be considered as parallel with the picture plane if we prefer that viewpoint.

THE PERPENDICULAR LINES

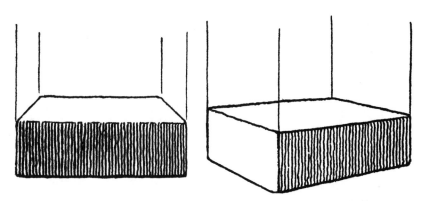

Now let us consider the "height" lines. This is easy. The third set of parallel lines or the "height" lines may be drawn straight up and down with no vanishing point to consider.

This is true because the "height" lines cut across our picture and we always see only this small segment of them no matter how far they may be extended up or down. The "height" lines might be compared with the upright mullions or bars of a window through which we look.

45

REMEMBER

All of a set of parallel lines in perspective meet at a point.
This point moves along the eye-level line when the object is turned.
The other set of parallel lines meet at another point.
Both points are on the eye-level line.
Height lines are up-and-down with no vanishing point.

PROBLEMS

Draw a book lying on the table.
Turn the book so that it lies in a different position and redraw.
Notice how the two vanishing points rearrange themselves each time the position of the book is changed.
Stand a brick on end and sketch it in this position. Show the direction of the "height" lines. Do they meet at a point?

STEP SIX

PLACING THE TWO
VANISHING POINTS

THE ERROR OF
CLOSE SPACING

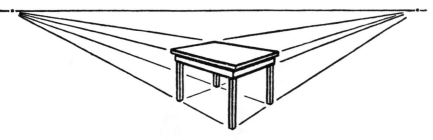

Vanishing points widely spaced. Correct.

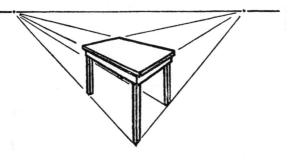

Vanishing points closely spaced. Incorrect.

It is good drawing to place the vanishing points well apart.

If the points are close together the drawing is not of a square object; it is diamond shaped. This is called "violent" or "warped" perspective.

It is a student's temptation to place the points close together, within easy range; thus the drawing has the wrong beginning and will always look wrong.

Place the points a long way apart even if it is an effort to do so.

49

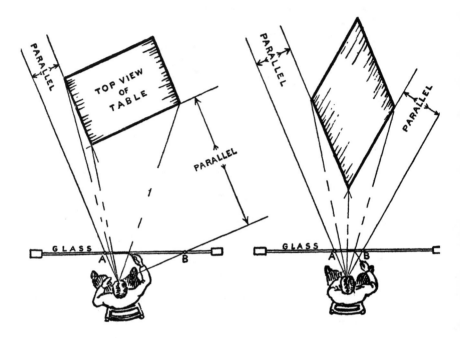

Let us suppose an artist sits in front of a window and traces on the window glass a picture of whatever he sees outdoors.

Now let us suppose there is a table out on the porch.

If we could look straight down from above we would see the artist (as shown in the picture on the left) tracing the table as he sees it through the glass. He is drawing right on the window glass.

The vanishing points of his drawing would be *A* and *B*. These two points are found where the lines pass through the glass when they are extended from his eye parallel to the two sides of the table.

Note how far apart the points lie.

If the points are too closely spaced (as in the right-hand picture) the table would have to be diamond-shaped to be parallel with the lines from the eye to *A* and *B*. This is why a square-cornered object looks out of shape when the points are too closely spaced. In other words the artist says in his picture, "This object is not square-cornered."

The drawings which resulted from these two conditions are shown on page 49.

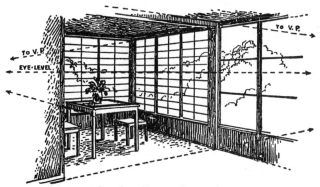

An example of well-spaced vanishing points

In freehand sketching it is not necessary to locate these points exactly. But remember; keep them far apart.

51

EXAMPLE OF VANISHING POINTS TOO
CLOSELY SPACED: THE WRONG WAY

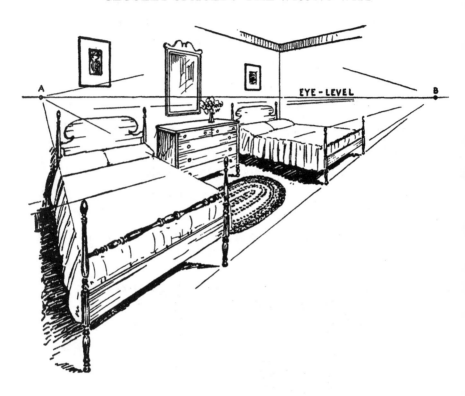

Sketch of a room where vanishing points *A* and *B* are too close together. Notice the warped shape of the bed.

To correct this error move either vanishing point *A* or *B* outward from the drawing and along the eye-level line.

Now let us see what happens.

EXAMPLES OF VANISHING POINTS WIDELY
SPACED: THE CORRECT WAY

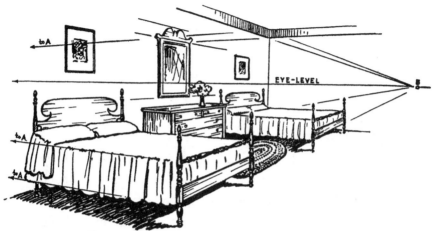

Sketch of same room with point *A* moved outward.

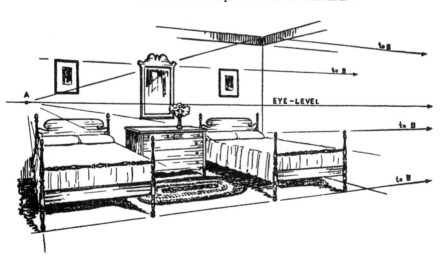

Room with point *B* moved outward.

The two drawings on the preceding page are examples showing the result of the vanishing points widely spaced.

The first drawing shows point *B* in the same position as in the previous sketch, but point *A* has been moved to the left in order to widen the distance between *A* and *B*.

This wide spacing of points gives a natural appearance to the furniture.

The second drawing shows the results when *A* remains unmoved and *B* is moved out to the right. When we do this we create a wide space between *A* and *B*.

Here again the result is a natural appearance of the furniture but a different appearing drawing.

Both drawings are pleasing from the standpoint of perspective. The different results produced show how this particular group of furniture appears from two different positions in the room.

The first drawing obviously was made when the artist was in a position where he could get a side view of the bed. The second drawing shows his position changed so that his view is more toward the foot of the bed.

If we hold these drawings before a mirror we can see the grouping of furniture as it appears from a similar position on the opposite side of the room.

We have discovered that the spacing of vanishing points is most important, not only in giving the drawing

a correct appearance but also to show different viewpoints of whatever we are drawing.

It may be interesting to know that this has been one of the problems in animated cartooning, where a background shows an interior in perspective and a figure is moving across it. The customary background used in animation is a single drawing. What appears as a figure moving across this background is a series of drawings made on transparent sheets placed over the background and then photographed.

When the figure moves across the background and is followed by the camera, the background should change in perspective as the camera changes its viewpoint.

Fortunately for the animater the attention of the audience is centered upon the moving figure and in many cases the unchanging background loses importance. To overcome this problem, however, new methods are being devised in the animation studios.

REMEMBER

If you place vanishing points close together you are not drawing a square-cornered object.

You are sure of a pleasing drawing if you space the points widely.

The vanishing point lies at the place where a line passes through the drawing. This line is one that extends from the artist's eye and is parallel to the line he is drawing.

Draw a candy box with vanishing points widely spaced.

Place points close together and redraw the box. Compare the results.

Experiment by tracing with a china marking pencil something that you see through the window.

When this is done move farther away from the window and notice that the object appears larger than your drawing.

Use the diagram of the artist and the window. Note the change that would take place in the size of his drawing if you were to move him closer or farther from the window. Would the position of vanishing points be changed?

STEP SEVEN

SHOWING HOW THE
VANISHING POINTS
MOVE IN RELATIONSHIP
TO ONE ANOTHER

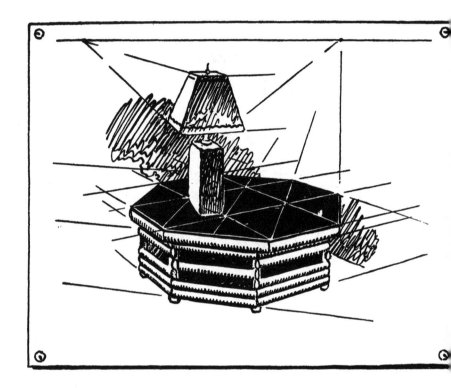

DIRECTIONS OF VANISHING POINTS

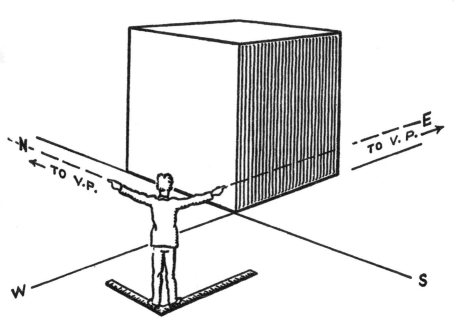

Stand in front of a cube (a brick or a building) and point arm's length in the direction parallel with one side of the cube. Let us assume that you are pointing toward the east. Now then, the adjoining side of the cube runs northward. Point in that direction with the other hand. You are now pointing at the two vanishing points of the cube.

Your two arms form a square corner (right angle).

If the cube is turned the vanishing points will change

their positions. You must now turn your body to meet these new directions. Your arms still form a square corner.

When the position of the cube is changed the relationship of the points must change. Let us see what this relationship is.

THE RELATIONSHIP OF THE TWO POINTS

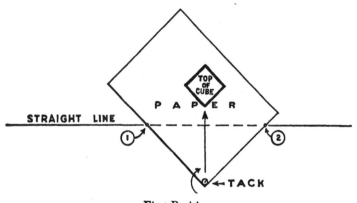

First Position

There are technical ways to determine the relationship between the two vanishing points, but for freehand drawing it is necessary to remember only the simple arrangement: a straight line; a sheet of paper tacked at the corner a short distance from this line.

The diagram above shows this arrangement; the tack represents the place where you are standing and the two

sides of the paper show the directions of your outstretched arms. This is the same arrangement as the diagram on page 59.

Now revolve the paper around the tacked corner so that the distance from the tack to the line is the same along the two edges of the paper (first position). Mark the two points where the edges cross the line (1) and (2).

These two points represent the relationship of the two vanishing points when a person is looking directly toward the corner of a building or any square-cornered object.

In a perspective drawing this line on which the two points lie represents the eye-level.

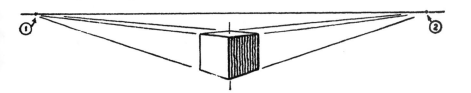

Above is the corresponding perspective drawing in which the object that is drawn has its vanishing points in the same arrangement as they are in the diagram— equally distant from the center.

Notice that the lighted and the shaded side of the cube appear the same in size.

We shall now change the position of the points: we shall notice how they move apart from each other and we shall see how the perspective drawing of the cube changes to meet these different positions.

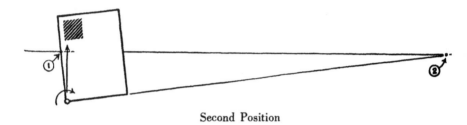

Second Position

Revolve the paper from the first position on the preceding page to the second position as shown above. Point number one moves toward the center which is directly above the tack.

Point number two moves away from this center at a much faster rate.

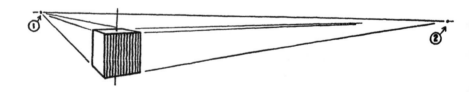

The cube is shown drawn with the vanishing points in this relationship.

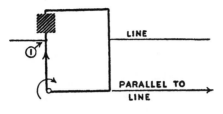

LINE

PARALLEL TO
LINE

Third Position

When the paper is revolved so that point number one reaches the center, point number two disappears. This is like the drawing of the railroad track where we have one-point perspective.

The line that determines point number two does not cross the line which represents the eye-level. Hence, no point.

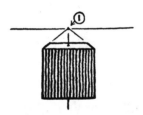

Here we have a drawing of the cube in this relationship of points. The cube has a single side facing us with the top drawn in one-point perspective.

This is the arrangement of perspective points that we use in making a sketch of a room while standing at the center and directly facing a wall.

63

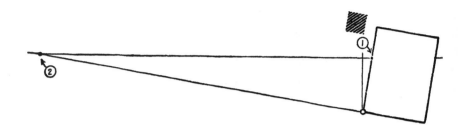

Fourth Position

Now revolve the paper still farther. Point number one passes the center and immediately point number two appears again on the line but in the opposite direction from its former positions.

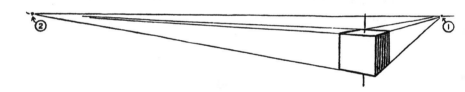

The cube drawn to this arrangement is like position number two except opposite in direction.

Remember in using this method that the diagram of the line and sheet of paper is not a perspective drawing but merely a method of showing how the two vanishing points may be moved in relation to each other—one moves slowly, and the other quickly.

It shows also that the two points should be spaced widely apart in a perspective drawing.

Notice that we cannot have both points on the same side of the drawing. As soon as we turn the cube in order to create that relationship we find that the point passes to the other side. One perspective point is on the left and the other on the right of the center of interest. This relationship does not hold, of course, in one-point perspective.

REMEMBER

When you point in the same direction as the line you are sketching, you are pointing toward the vanishing point of that line.

The two vanishing points lie on the eye-level line out in the direction of the two lines forming the square corner on which you stand.

As the object is turned this corner revolves around the point on which you stand. You can thus follow the change in direction of the points.

The two vanishing points hold opposite sides of the center of interest. They cannot get together.

PROBLEMS

Place books so that they lie in different positions on your desk. Now point toward the vanishing points of each book.

Make a drawing of a box and then show how its vanishing points would be determined by the diagram.

Reverse the process by choosing one of the four positions of the diagram and then making the drawing accordingly to meet this condition.

STEP EIGHT

BUILDING PERSPECTIVE
WITH BRICKS

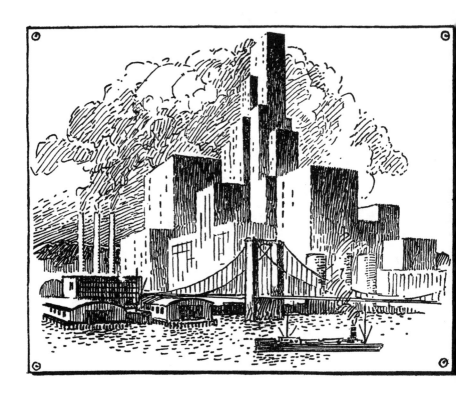

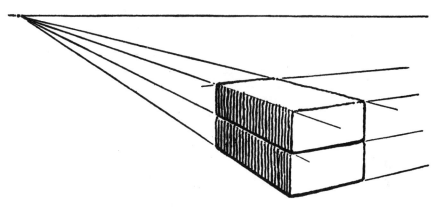

Place a brick on the table before you. Sketch the brick with its parallels extended to their vanishing points.

Place a second brick on the first. This second brick adds more parallel lines which in turn can be extended to the two vanishing points of brick number one.

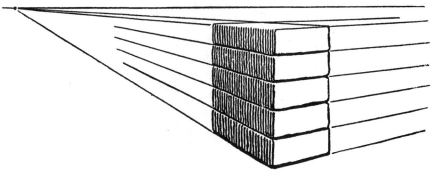

Add more bricks.

69

As they approach the level of your eye the top of the upper brick appears narrow because the lines determining that surface are coming closer together.

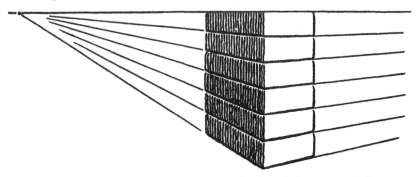

When the pile reaches your eye level the top of the brick can't be seen at all because the lines of the two parallel edges have come together.

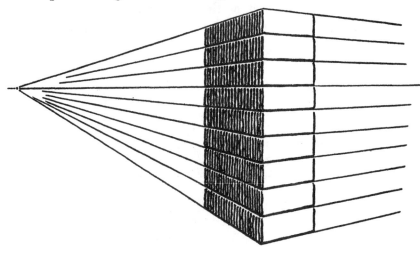

Now pile the bricks higher than your eye-level.

The edges tilt downward in order to reach the vanish-
ing point.

This is true no matter how high we pile them.

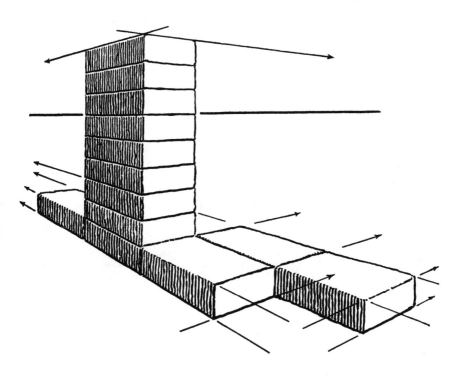

Lay several more bricks on the table, end to end or
side against side.

The new lines formed by the additional bricks all
extend to the same vanishing points.

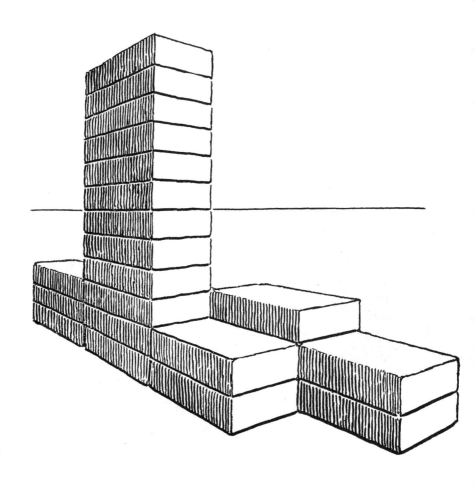

Place more bricks on top of the ones you already have.

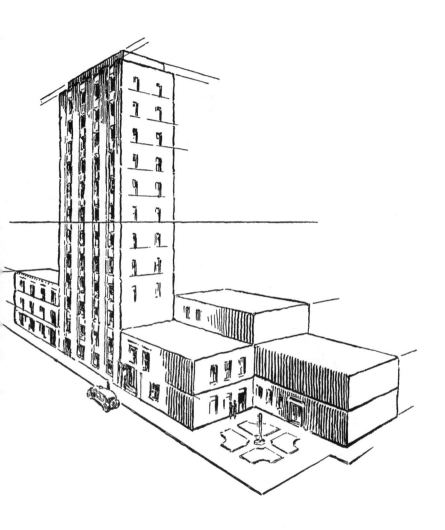

We now have a group of buildings drawn in perspective.

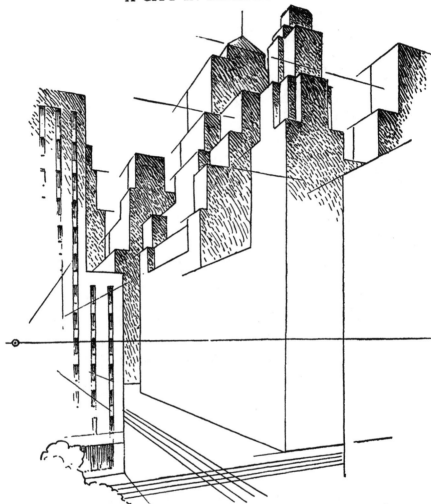

Bricks or blocks are arranged end to end and side
against side. Now add more at the top, building the
piles to various heights.

A city can thus be drawn by the use of two perspective points on a line of vision.

When you sketch a city from the window of a high office building, keep in mind that the buildings you see are nothing more than bricks piled up in the manner just explained.

CHANGING THE EYE-LEVEL

We now wish to draw the same grouping as we should see it from the street level.

First, decide how high a person's eye-level would be if he were standing beside one of the buildings.

The height of his eyes would be about where the mark is on the door.

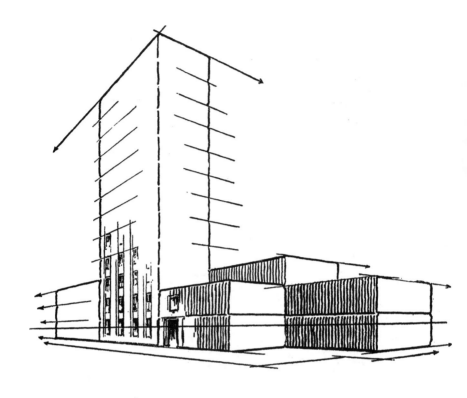

Now we redraw the buildings, lowering the eye-level so that it passes through the mark on the door. The vanishing points remain on the line in their same relative position as before. The upright lines of the buildings are in the same position. Only the horizontal lines change for this change of eye-level.

Different views of the buildings may be drawn in this manner by raising or lowering the eye-level.

REMEMBER

All parallel lines in a perspective drawing meet at one point regardless of how many lines there are or how high they may be from the ground.

All horizontal lines merge into the eye-level line when they reach the eye-level.

Parallel lines that are below the eye-level tilt upward; when above the eye-level they tilt downward toward the vanishing point.

A building can be considered as a stack of bricks.

Whoever can draw bricks can draw a city.

PROBLEMS

Place books in a stack on your desk so that the top edge of the top book reaches your eye-level. Make a sketch.

Now stand up and sketch the same group.

Place the books on something that is above the eye-level and sketch them.

Compare the three drawings.

Make a drawing of some building that you can see from your window. Draw it as if it were bricks.

Now draw a whole group of buildings in this manner.

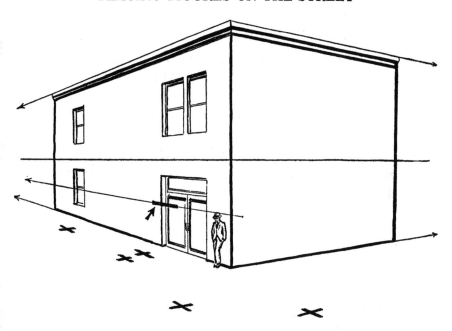

We have a drawing of a building and we wish to sketch people in various places on the street so that they will be in correct proportion with the building.

The places where we wish to sketch these people are marked with X.

In order to place figures on the street we must first know how high a person would be compared with the height of the building.

We know that the average person would reach a cer-

81

tain height on the doorway, so we make a mark at that place.

A line passing through this mark to the vanishing point of that wall would give the height of all persons standing close to the wall of the building.

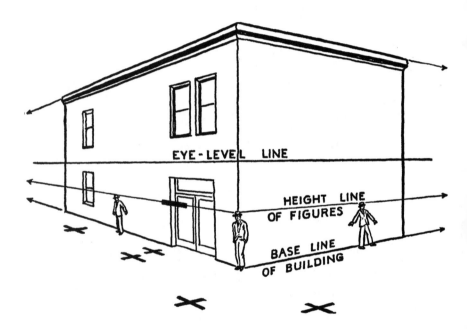

A person at the corner of the building would be the height of the line where it touches the corner.

From this height at the corner extend a line in the other direction to the vanishing point of the other wall.

A person standing close to this wall would be the height of this line.

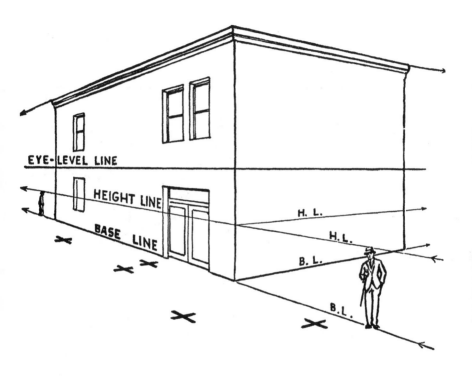

Extend either of these height lines past the corner of the building. Also extend the base line of the building.

The distance between these two lines is the height of a person standing anywhere on the lower line.

Now to find the height of a person standing on the spot marked X.

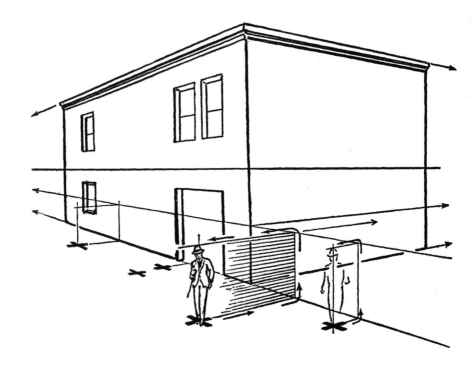

Start from the X and follow a line that goes to the other vanishing point. Stop where it crosses the lower height (or base) line. Then, go straight up until you reach the upper height line. Next, turn back on a line that comes from the vanishing point and continue until you are above the X. These directions are shown with arrows.

The distance from the X up to this line will be the height of a person standing on the X.

This is true with all the places marked X.

This method is like building a man-high wall or fence out from the line of the building to each spot marked *X*.

This method can, of course, be used in placing objects, as well as people, in their correct heights; for instance, autos, horses, streetcars, and the heights of chairs and tables or persons when seated.

Often when making an illustration it is desirable to show people in the foreground with only their heads and shoulders appearing in the picture. By this method we can determine correctly just how much of the person will be shown.

A SHORT-CUT METHOD

Here is another way to find the height of a person standing at the place marked by the cross.

Before doing this we must have two things: the eye-level line and another person somewhere on the drawing. Anything that is the same height as a person may be substituted.

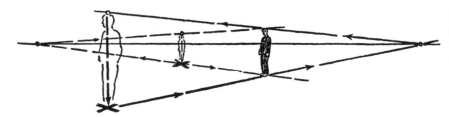

Draw a line from the cross straight to the feet of the figure and extend it to the point where it crosses the eye-level line.

Draw another line starting from the place where the first line crosses the eye-level line. Extend this line to the head of the figure and then on until it is above the X. A line from this point straight down to the X is the height of the figure.

This is another way of making the "man-high wall" extending to a vanishing point on the eye-level line. It can be used for drawing any standard-height objects resting on the ground (or floor) such as seated figures, chairs, tables in a dining hall, or autos on the street.

Notice in the above diagram that the method holds true whether the X is in the foreground or in the background beyond the figure. It makes no difference where the figure is placed, or whether or not his head is above or below the eye-level line.

Any standard of measurement may be used. The height of a person is found to be a convenient measuring stick.

This is a quick and handy method.

86

AVOID CROWDING

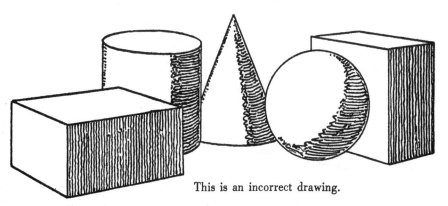

This is an incorrect drawing.

Here we have a group of solid objects.

We discover that the objects could not be arranged in this position because they are so closely crowded that they merge into one another.

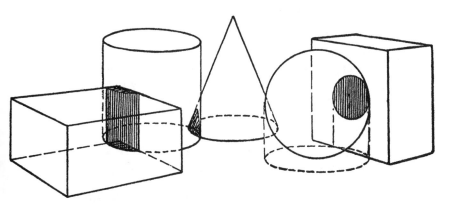

This is the same group of objects. The shaded areas show where the objects overlap.

87

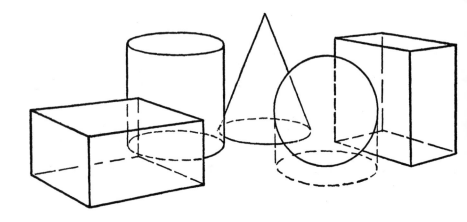

Here is the group redrawn correctly showing the bases clear of interference from one another.

Remember

Before placing figures in a drawing we must find the correct height of one figure.

We build an imaginary man-high wall to determine the height of figures in a drawing.

Other objects can be placed in a drawing in the same manner that we place figures. A standard of height is the only thing we need after the background has been sketched in.

Problems

Make a simple drawing of a man standing in the doorway of a one-car garage. Sketch two or three persons walking along the sidewalk.

Show the height of an automobile in the entrance of the garage.

Show the height of the same car when in the street. Show it in different positions along the street.

Draw a number of figures standing about on an open prairie.

CENTER OF INTEREST

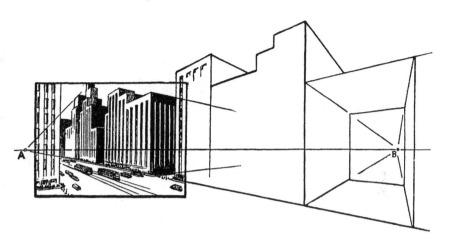

There is danger of including too much area in a drawing.

On the left of the diagram (within the frame) the drawing of the street looks quite correct in perspective.

When we extend the street to point *B* the buildings become misshapen.

Now if we extend the drawing to the left beyond *A*, the part we extend will likewise become warped.

The reason for this is that what the eye takes in is only a small area. Beyond this area the picture grows blurred and distorted.

When we extend a drawing beyond this center of interest it is necessary to turn our attention to the border

of our vision. By doing this, we form a new picture.
The first picture now passes to the edge of our vision or
beyond. The new picture requires a rearrangement of
vanishing points.

Remember that the two vanishing points will not al-
low you to make a panorama drawing.

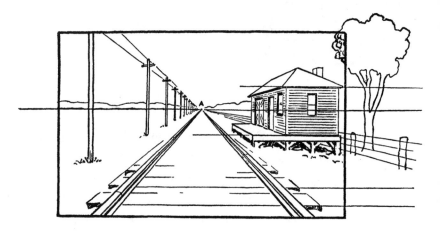

Take a further example and look down the track.
The eye sees the part of the picture shown within the
frame.

The area outside the frame is seen out of the so-called
corner of the eye.

In this case there is the one vanishing point *A;* the
other set of lines are parallel with the horizon line. See
page 63.

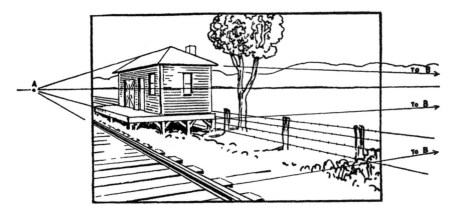

If our attention is called to the tree we turn our eyes so that the tree becomes the center of interest. Vanishing point *A* has moved to the left of our vision and vanishing point *B* comes in at some distance to the right.

This shows how new pictures are formed with a new arrangement of vanishing points when we give attention to objects that lie at the edge of our vision.

If we wish to keep our drawing correct in perspective, we do not attempt to take in a wide area.

The drawing on the opposite page is an example of the arrangement described on page 63. We change it so that it conforms to the arrangement shown on page 62. The first of the above drawings of the track represents the arrangement of the cube when it is turned to a position of one-point perspective. The second position represents the cube turned so that the vanishing point has moved toward the left.

ROOFS

Often a group of roofs have the same slope. The lines of these roofs meet an up-and-down horizon line—if such a thing can be imagined.

This up-and-down horizon passes through the true vanishing point (A) of the building. This can be better understood by turning this drawing on its side.

The roof of the building H lies in the opposite direction to the other buildings; hence the vanishing points of this roof lie on a line above and below through vanishing point B. The farther apart these up-and-down points are spaced, the steeper the roofs.

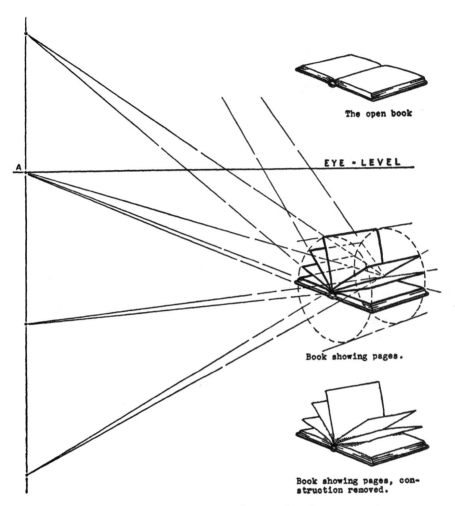

The open book

EYE - LEVEL

Book showing pages.

Book showing pages, construction removed.

The open book or the lid of a cracker box opened to different positions is a further example of the principle used in drawing the roofs. Note the use of the cylinder in the above drawing.

REMEMBER

There is danger of including too much area in a drawing.

Two vanishing points will not allow you to make a panorama drawing.

A new picture is formed each time our attention is turned to a different point of interest.

The sloping lines of roofs meet at points above and below the normal vanishing points of the building.

PROBLEMS

Sketch a book that lies on the desk before you. Note the two vanishing points.

Sketch more books on either side of the first book. Use the same vanishing point.

How far can you extend this row of books?

How many appear well-proportioned?

Draw the end of a room with a table at the right-hand side of the drawing.

Now make another drawing of the same room end but change the view so that the table appears on the left-hand side of the drawing. What adjustment is necessary for the position of the vanishing points?

Make a sketch of a log cabin. Show the vanishing points of the roof. On the same drawing make another cabin with the roof facing in the opposite directions. Show the vanishing points of the roof.

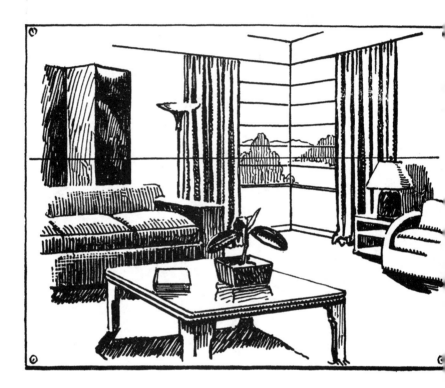

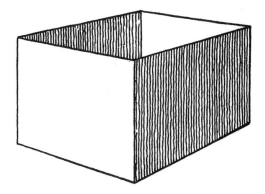

Here we have an open box.

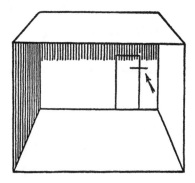

Lay the box on its side and sketch it, looking directly into the open end.

If it were large enough the inside of the box could be the interior of a room.

Sketch a door in the far end. If you were standing in this room your eye-level would be about the height of the mark on the door.

99

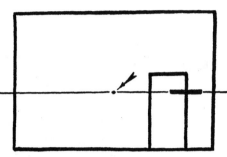

Draw the end of the box as if it were a room into which you are looking. You are standing at the opposite end and your eye-level is the same height as the mark on the door.

The vanishing point would be at the center of the wall and on the eye-level, assuming that you are standing at the center of the opposite wall.

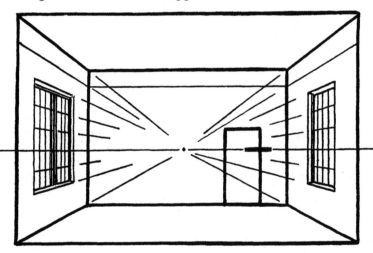

The inside of the box can now be changed to the in-

terior of a room by drawing the walls, floor, ceiling, and windows with lines that pass through this vanishing point.

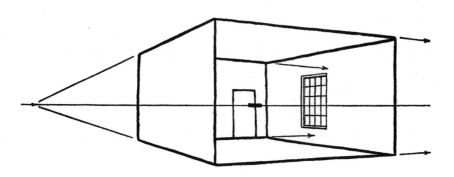

Now turn the box so that it is necessary to use both vanishing points.

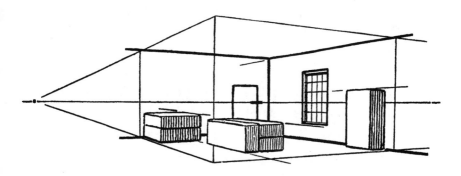

Placing the furniture in the room is as simple as placing bricks around.

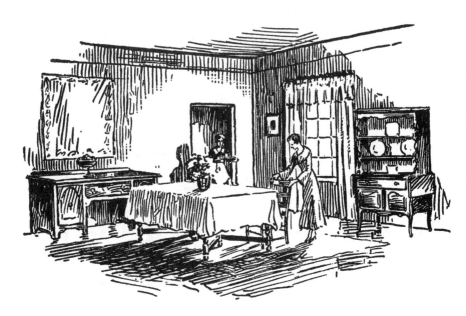

The open box can be transformed into an interior of a room. The bricks are transformed into furniture.

People can be placed about the room by using the same method that we used when we placed the figures on the street beside the building.

We have created a room by the use of bricks and a box. It is surprising how many of our drawings can be built around these simple objects. When the drawing is irregular in shape like a grand piano we can place it correctly into the perspective of a room by first drawing it as a large box. With the lines of the box as the basis of our drawing we can then bring out the lines of the piano correctly placed.

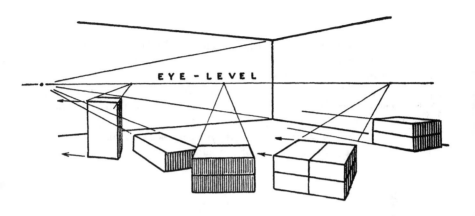

Pieces of furniture can be placed facing any direction provided their vanishing points are all on the same eye-level as that used in sketching the room.

If the vanishing points of the furniture are not the same as those of the room it means that the furniture has been placed cornerwise, not square with the room.

REMEMBER

An interior of a room may be considered as the inside of a box.

When we stand in the center of a room and look at the center of a wall we have before us the subject for a one-point perspective drawing.

Pieces of furniture can be considered as bricks placed around the inside of a box.

The box and the bricks within it have their vanishing points on the same eye-level line regardless of the direction in which the bricks may lie.

103

Draw a brick. Change it into a table. A bookcase. A day bed.
Place books haphazard upon the table. Now sketch them in these
positions. Where will all their vanishing points lie?

Sketch the inside of a room as if it were a box placed at a height
where your eye-level is the same as that of a miniature person
within the room.

Place bricks within a box. After you have sketched this grouping
change the bricks into pieces of furniture.

STEP TWELVE

FINDING THE CENTER

DIVIDING SPACES
INTO HALVES

PRACTICAL APPLICATIONS

HOW TO FIND THE CENTER

Place a brick upon your drawing table.

With chalk draw crosslines on the face of the brick from corner to corner. These crosslines are called *intersecting diagonals.*

The lines cross at the center of the face, marked *C.*

Draw other crosslines on the sides of the brick and on the ends.

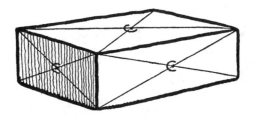

Sketch the brick in perspective showing these crosslines.

The point where they cross always indicates the center (C) of the side regardless of the position of the brick.

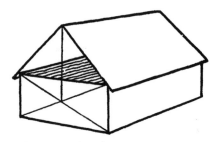

Fold a piece of cardboard and place it on the brick.
This makes a house.

Draw it in perspective.

The point of the roof is directly above where the two
end lines cross.

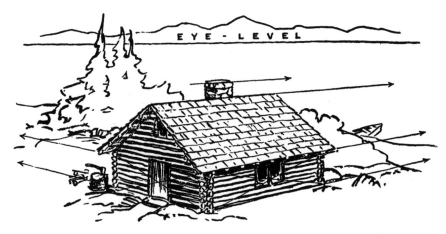

There is a door at the center of the end and a window
at the center of the side.

These are determined by the crosslines or intersecting
diagonals.

THE USE OF DIAGONALS

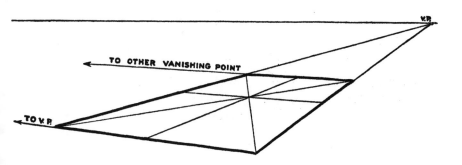

Sketch the top of the brick omitting the sides and showing the crosslines and the dividing lines going to the vanishing points.

A rectangle or square divided in this manner has a great number of uses in drawing.

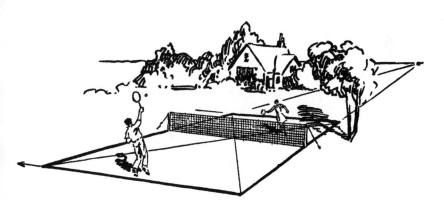

The top of the brick used as a tennis court.

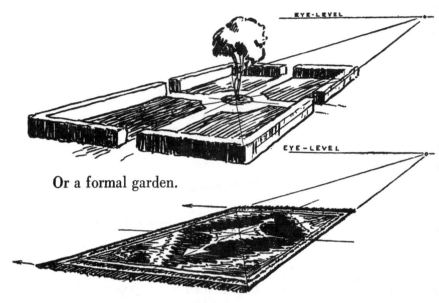

Or a formal garden.

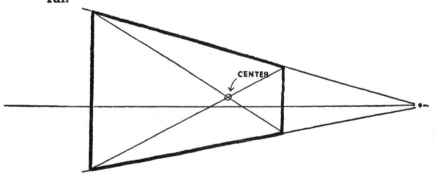

Or the basis for a rug pattern, or whatever we may choose. These intersecting diagonals are always useful.

The side of the brick in perspective drawn with cross-lines showing the center.

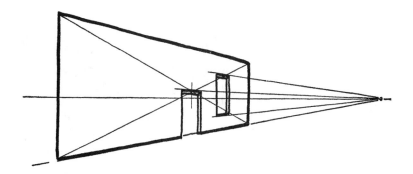

The side of the brick as the side of a building with the crosslines locating the door at the center.

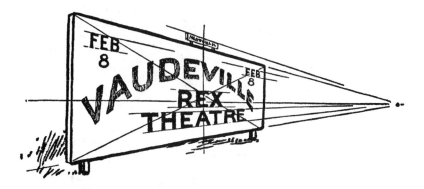

The side of the brick may be a billboard, or whatever we may choose. We will find crosslines useful in many ways.

In the drawing of the billboard note how the perspective center is found to be some distance to the right of the center by measurement.

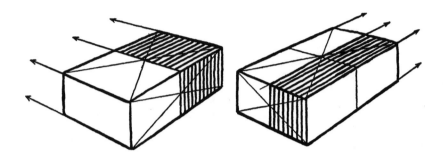

The top of the brick has crosslines. Lines drawn
through the center point to either vanishing point divide
the brick in halves.

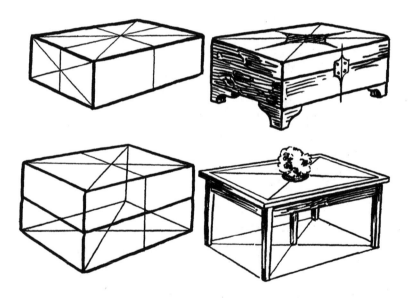

Bricks with crosslines can be used as a basis for a
large number of our perspective drawings.

112

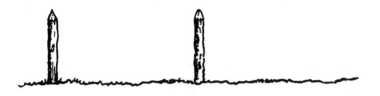

We have two posts the same height.

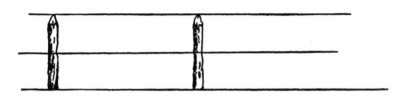

We now draw three parallel lines: one along the top, one through the center, and one along the base of the posts.

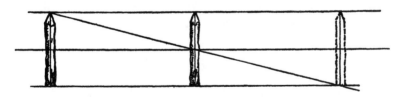

Now if we draw a line from the top of the first post straight through the center of the second post we discover that it meets the base line where the third post should be.

113

This is our crossline method used in a different way. In this case we use it to locate the fourth side when we have three sides and the center lines of the brick face.

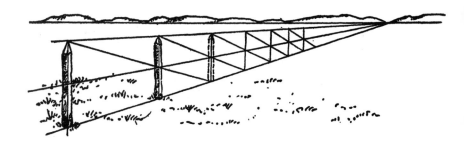

The same relationship is true when we draw the row of posts in perspective. With two posts placed we can draw as many as we wish—correctly spaced.

This rule also holds true when the divisions lie flat like blocks of pavement or the top of a string of freight cars. The dividing lines in this case recede to the other vanishing point. These dividing lines are represented by the posts in the drawing.

REMEMBER

Crosslines are useful to find the center of a square-cornered surface though the surface may or may not be drawn in perspective.

Bricks with crosslines can be used as a basis for a large number of our perspective drawings.

When two objects of the same height are placed in a perspective drawing we can add as many more as we wish—correctly spaced.

Crosslines are called "Intersecting Diagonals."

114

Draw a table in perspective. Now place a vase of flowers exactly in the center.

A drain hole is in the center of a square-cornered tub. Show this in a perspective drawing.

There is one window at the end of a room. The window has cross-bars or mullions and four panes of glass. Show this with one-point perspective. With two-point perspective.

Draw a row of trees equally spaced but of different heights. (*Suggestion:* Locate the position of the trees as if they were posts; cover them with foliage of different heights.)

A sidewalk is made of black and gray flagstones alternated. Make a drawing of this walk.

A train of boxcars is moving across the prairie. Draw a picture of the train.

CYLINDERS IN PERSPECTIVE

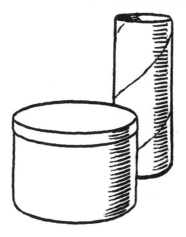

Place a coffee can and a mailing tube on the table.
These are cylinders.

The tops and bottoms of these cylinders are circles.

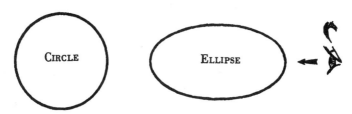

Close one eye; hold this page edgewise and look at
the ellipse from the direction indicated by the arrow.
In this position the ellipse appears circular. The circle
appears as an elipse.

Thus we find that when we look at any circle from
the side it appears elliptical.

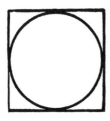 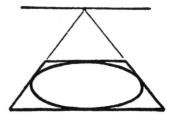

The above illustrations show a circle in a square and the same circle in the square when it is drawn in perspective.

The circle drawn in perspective becomes an ellipse.

The ends of cylinders when drawn in perspective become ellipses.

DRAWING THE ELLIPSE FREEHAND

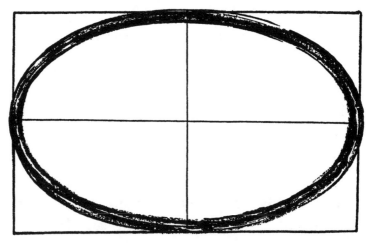

Make a rectangle the desired length and width of the ellipse. The ellipse will touch the rectangle at the center point of each of its sides.

With the rectangle as a guide practice filling in the ellipse with a free pencil line. With a little practice it is surprising how closely the freehand line will approach a true ellipse.

THREE MECHANICAL WAYS TO MAKE AN ELLIPSE

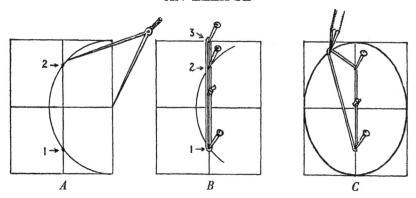

A B C

Make an ellipse to fill the space *A*.

First, with a pair of dividers, find where the circle (shown in *A*) crosses the long center line. It crosses at points 1 and 2.

Drive pins at these points and a third pin (3) at the end of the center line.

Tie a linen thread tightly around the three pins. (shown in *B*)

Pull out pin number 3 and trace the ellipse with a pencil. (shown in *C*) Keep the thread taut.

121

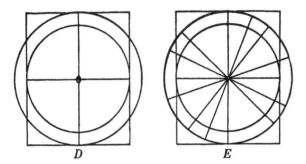

D E

Here is another way to make an ellipse to fill space *A*.

Make two circles with their center at *O*. One circle has a diameter which is the width of the space, the other has a diameter of the length. (shown in *D*)

Now draw lines like spokes of a wheel. (shown in *E*)

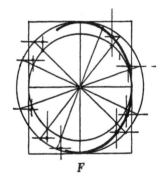

F

Where the spokes cross the small circle make lines parallel to the length line. Where they touch the large circle draw the lines parallel to the width line.

The ellipse lies where these lines cross. (shown in *F*)

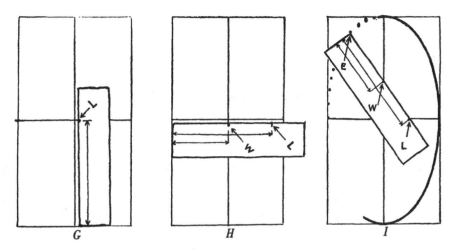

G H I

Here is another way to make an ellipse of a certain size.

Take a strip of paper and mark off half the length of the given space. Mark it L as shown in G.

Next place the paper along the width line and mark with a W half this width as shown in H.

Now move the paper so that the point L touches the width line and the point W touches the length line as shown in I.

The end of the paper (marked E) shows where the ellipse lies.

Keep moving the paper around until you have indicated as many points as you desire.

This method is accurate for ellipses of any size. In mechanical drawing a French curve is helpful after the points are located.

THE LONG AND SHORT AXIS

The longest line through an ellipse is called the long axis.

The shortest line through an ellipse is called the short axis.

Where the long and short axis cross each other they form square corners.

We will consider the long axis forming the crossbar for the letter T, the short axis the stem of the T.

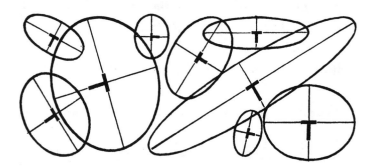

This relationship between the axes and the T holds true regardless of the size, the shape, or the position of the ellipse.

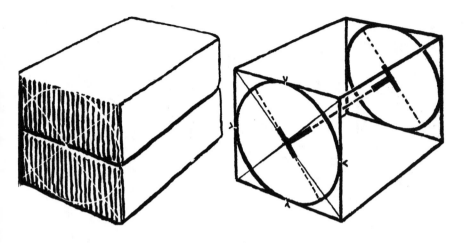

Place one brick on top of another. We assume that the ends make a square.

Draw crosslines on the ends and thus find the center. This is the center of a circle that touches the four sides of the square.

The circle may be considered as the end of a cylinder that runs the length of the brick. Draw the other circle on the opposite end.

A line drawn between the centers of the two circles is the center of the cylinder or the axle for the two wheels.

The axle of the wheels is an extension of the small axes of the two ellipses and the stem of the T.

The long axis forms the crossbar of the T.

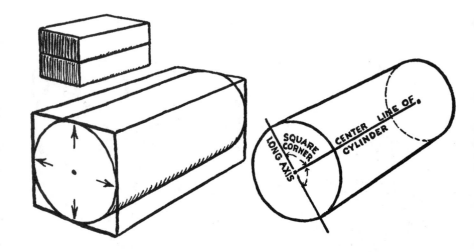

We begin by assuming that the ends of the two bricks form a square when the bricks are placed one on top of the other.

Sketch the bricks in perspective. The circle at the square end becomes an ellipse touching the square (in perspective) at the center of each side.

A line drawn from the center of the circle to the vanishing point would be the center line of the cylinder or the axle for the two wheels.

A line through this same center intersecting this axle line squarely would be the longest line (or long axis) of the ellipse.

This long axis forms a square corner (right angle) with the center line of the cylinder.

It makes no difference in which direction the cylinder

126

lies, or whether or not it is standing on end, the long axis of the ellipse forms a **T** with the center line of the cylinder. The short axis lies along this center line. The short axis of the ellipse becomes the center line of the cylinder.

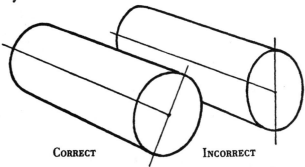

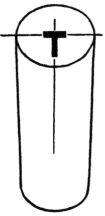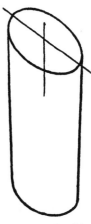

CORRECT INCORRECT

Draw a cylinder in perspective. Then, turn the paper so that the cylinder is upright.

If it looks like this it is quite correct.

If it looks like this it is incorrect.

127

A CONE ON ITS SIDE

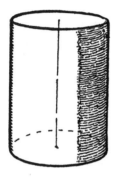 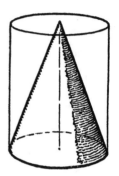

Cones can be made from cylinders as shown in the above sketch.

Now we will draw the cone lying on its side.

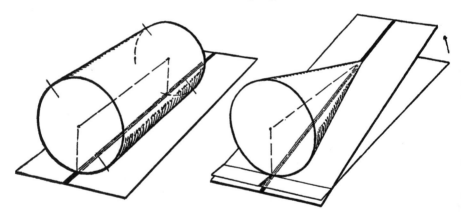

The cylinder is first placed on its side lying on the black line as shown.

A cone is then made from the cylinder while it is in this position.

We wish to place the cone so that it rests on the flat surface. To do this we tilt the surface up until it rests against the cone. The point of the cone is now on the black line.

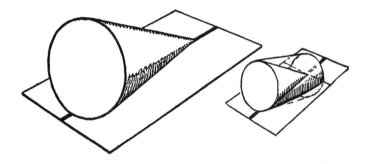

Now let us turn this whole arrangement so that the surface is again level and the cone remains resting upon it.

A cone therefore may be thought of as a cylinder one end of which has been pressed half its diameter into the surface on which it rests. The cone is then made from this cylinder.

REMEMBER

A circle in perspective appears as an ellipse.

A cylinder in perspective may be considered as two wheels with the center line forming the axle.

The long axis of the ellipse forms the crossbar of a **T** with the axle.

PROBLEMS

Draw an ink bottle. Show that it is made up of cylinders.

Sketch a group of kitchen utensils. Now place them on their sides and sketch them in this position. Keep in mind that you are drawing cylinders.

Make three ellipses with their axes 4 by 6 inches. Use a different method for making each ellipse.

Trace on transparent paper one of the ellipses you have drawn. Place this tracing over the other ellipses. How do they compare?

Draw cones on their sides lying in different directions.

STEP FOURTEEN

PRACTICAL USES
OF CYLINDERS
IN DRAWING

DIVIDING THE CIRCLE

DRAWING OBJECTS IN PERSPECTIVE

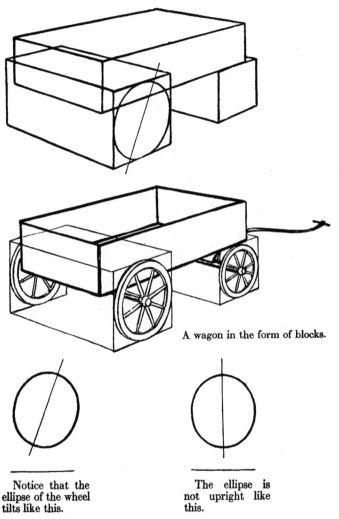

A wagon in the form of blocks.

Notice that the ellipse of the wheel tilts like this.

The ellipse is not upright like this.

The long axis of the ellipse is tilted to form a **T** with the **axle of** the wagon.

DRAWING AN OLD-FASHIONED AUTOMOBILE

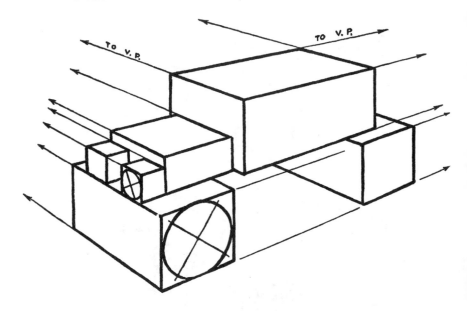

We will now draw an old-fashioned automobile.

The general outline is made up of different-shaped blocks drawn in perspective relationship.

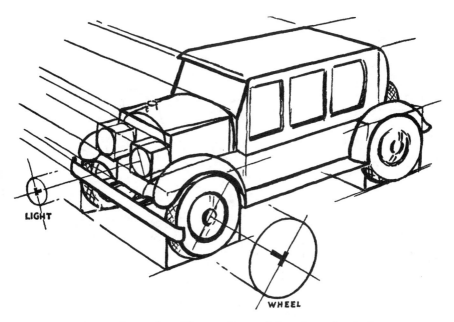

LIGHT

WHEEL

Notice how the ellipses formed by the wheels have their long axes lying in one direction while those of the lights lie in an entirely different direction. Notice that in both cases the long axis forms a **T** with the center line of the cylinder.

PRACTICAL USES OF CYLINDERS

We discover in drawing that a great many familiar objects are cylinders. Our cooking utensils, chinaware, lamps, vases, bottles, canned goods, automobiles, and pencils all express some use of the cylinder.

The following page shows a few examples of cylinders used in different ways.

135

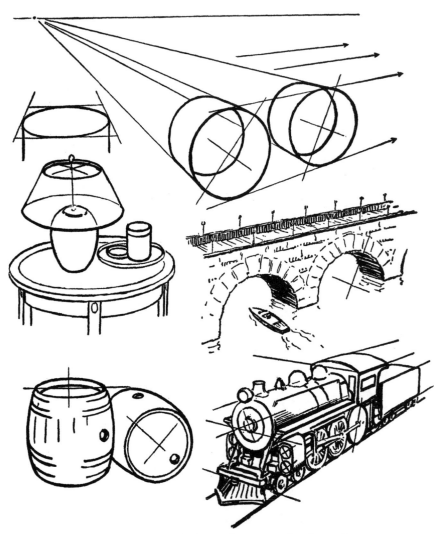

The bridge is made from the two cylinders above.
The boiler of the locomotive, the cylinder-heads, and
wheels are made by drawing cylinders.

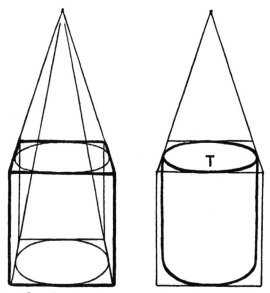

When sketching an upright cylinder it is best to consider it as if it were in a square box with the vanishing point directly opposite (like the railroad tracks). Both sides of the cylinder should be upright and parallel.

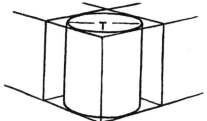

When the box is drawn in two-point perspective the cylinder within it remains in the same position as in the one-point sketch. The long axis always forms a **T** with the upright line of the cylinder.

137

THE UPRIGHT CYLINDER

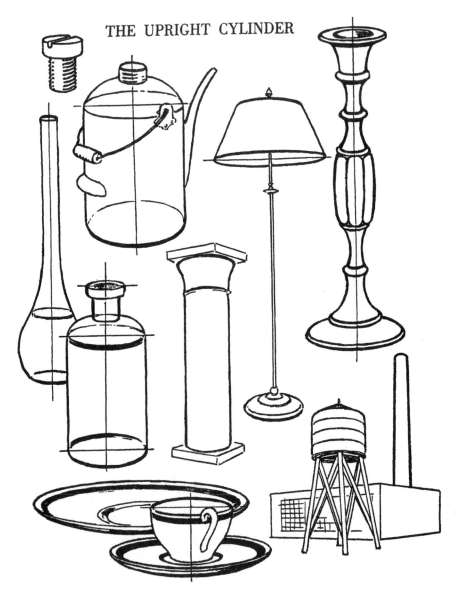

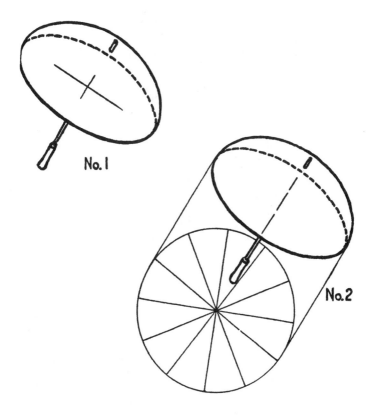

No. 1

No. 2

No. 1 is an umbrella without ribs. Now to give it ribs.

Extend the lines parallel to the handle of the umbrella (No. 2) starting from the farthest ends of the ellipse. Fill the space between these two lines with a circle. Divide the circle into equal spaces. The dividing lines represent the ribs of the umbrella—top view.

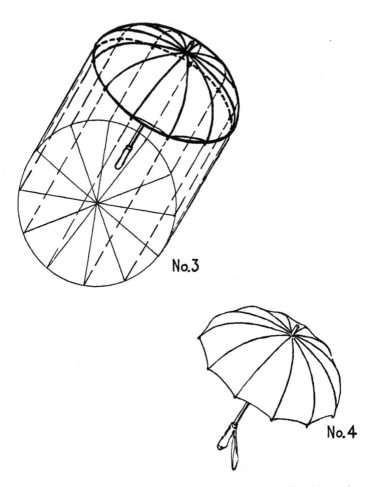

No.3

No.4

Draw parallel lines from the ends of these lines (No. 3) to the edge of the umbrella. This shows where the ribs start. Draw them around the curved surface of the umbrella so that they cross where the handle protrudes.

No. 4 shows the finished umbrella.

Use this same method to locate the spokes of a wheel, the fluting of a column, the design on a dish. There are some examples on the next page.

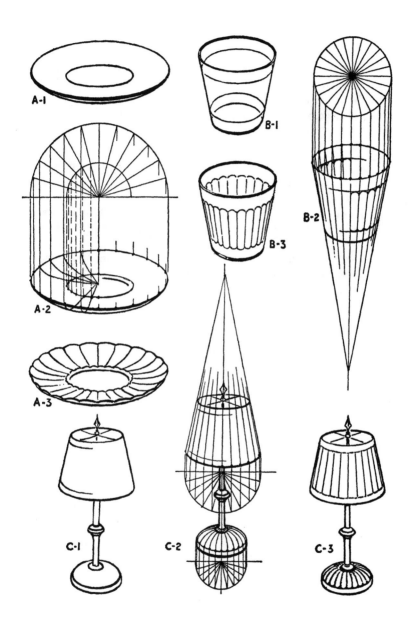

A-1

B-1

A-2

B-3

B-2

A-3

C-1

C-2

C-3

Bricks and mailing tubes have a great deal of importance. They are to be found in most perspective drawings.

The top of an upright cylinder is drawn in the same way regardless of the direction in which the cylinder is turned.

PROBLEMS

Make a sketch of a drain pipe standing on end. Lying on its side.

Make a sketch of a two-wheeled auto trailer.

Make a sketch of a railway tank-car.

Arrange a group of the following objects and sketch them: a round bottle, a spool of thread, a cup and a saucer, a candle in a candlestick.

Make a drawing of an ear of corn with even rows of kernels.

Draw a Doric column.

STEP FIFTEEN

DIVIDING A SURFACE
IN PERSPECTIVE

DRAWING A CHECKERBOARD

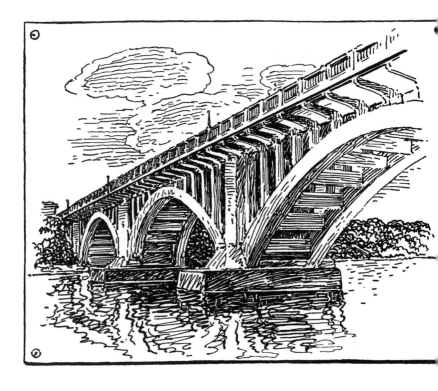

DIVIDING A SURFACE

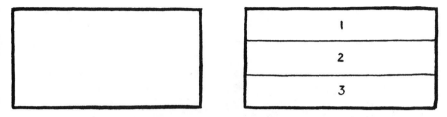

Draw horizontal lines dividing the face of a brick into three equal parts.

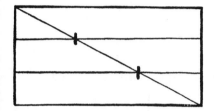 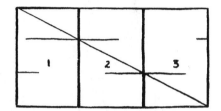

Now draw a line from corner to corner. Draw upright lines where the lines cross.

These lines will also divide the brick into three parts, upright instead of horizontal.

This holds true for four equal parts, or five, or as many as we wish to make.

DIVIDING A SURFACE IN PERSPECTIVE

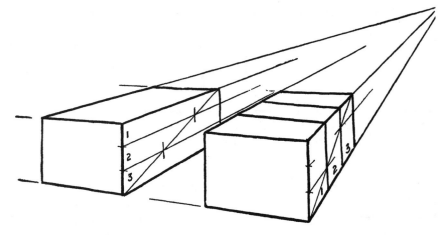

When the brick is drawn in perspective this method of dividing still holds true.

The spacing of the upright divisions is correct according to perspective.

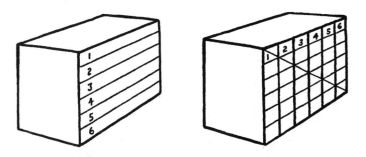

This holds true for as many divisions as you wish.

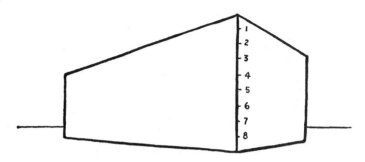

Let us draw a building with eight rows of windows equally spaced.

First divide the line of the corner into eight equal parts.

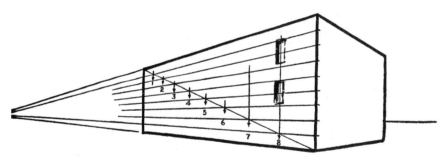

Extend lines from these points to the vanishing point of the building.

A line from corner to corner (like the one on the brick) will divide the wall into eight equal parts.

147

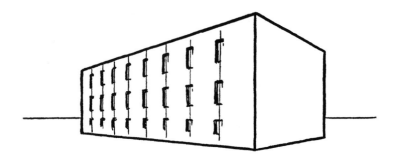

We have thus spaced the centers of the windows as they appear in perspective.

This method can be used for a row of columns, buttresses, panels, trees, or in any other case where it is necessary to divide a length into equally spaced parts.

DRAWING A CHECKERBOARD

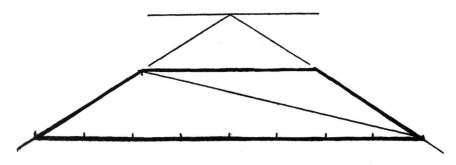

When drawing a checkerboard in one-point perspective, first divide the near or far side into eight equal parts.

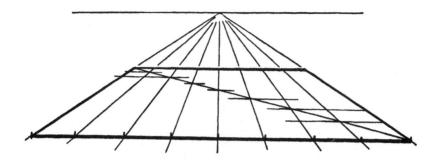

Lines to the vanishing point divide the board into eight parts.

A diagonal line crosses each of these divisions.

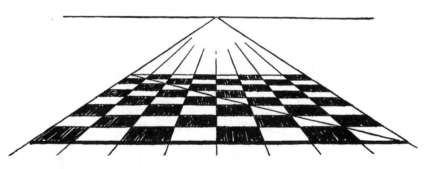

Where the lines cross, draw horizontal lines. These form the checks according to perspective.

A CHECKERBOARD IN TWO-POINT PERSPECTIVE

In the problem of the two-point checkerboard we have two sides to consider, both of which recede to a vanishing point.

149

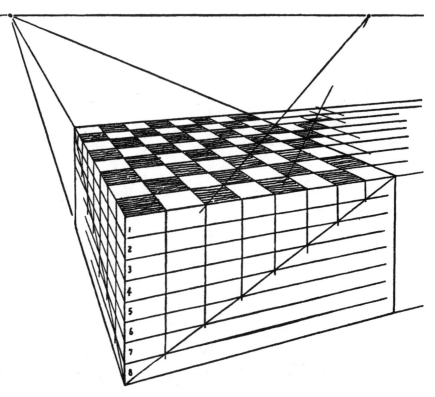

If we wish to draw the checkerboard in two-point perspective, let us consider the board as if it were the top of a box.

Now we use the same method we used on the building and divide the sides of the box, each side into eight equal parts.

We carry the upright lines over the top of the box and on to the vanishing points. These lines form the checks in correct perspective.

The area can be increased by drawing a line corner-wise through a row of checks out beyond the board. The diagram shows this method.

If our drawing is correct the lines drawn cornerwise will meet on a new set of vanishing points on the line of vision.

This checkerboard method is valuable in drawing linoleum and tile floors, rug patterns, and paneled ceilings.

For ceilings turn this drawing upside down.

PERSPECTIVE WHEN SPACING IS IRREGULAR

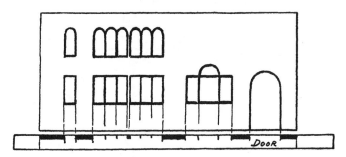

When the building has an irregular spacing of windows the diagonal method can be used in the same manner as in even spacing.

Take a strip of paper and mark the spacings of doors and windows, using the side elevation of the building for measurement.

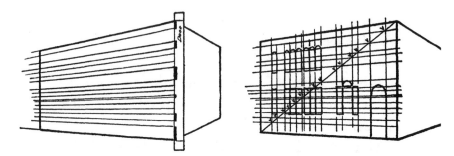

Sketch in the building so that the height of the near corner is the same length as that of the strip of paper.

Mark off these spacings and extend lines from these marks to the vanishing point of that side of the building.

A diagonal line will cross at the correct spacings of the doors and windows.

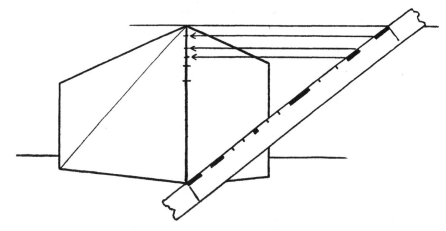

The building can be drawn smaller if desired. In so doing the measuring strip does not necessarily have to be made correspondingly smaller.

Sketch the building the size desired, then draw a horizontal line out from the upper corner of the building and fit the measuring strip between this line and the lower corner of the building as shown.

The spacings are then carried across to the building by the use of horizontal lines.

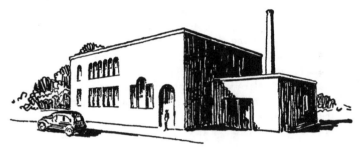

THE FINISHED BUILDING

OTHER METHODS

Another method used for spacing is shown on page 201.

There are many methods that can be used to divide uneven spacings for perspective drawings. These are omitted here, but can be found in technical books on perspective. The method given here is simplified, practical, and easily memorized.

A surface divided one way can be equally divided the other way by the use of a diagonal line. This diagonal method is extremely useful.

If the divisions are irregular the method still holds true.

PROBLEMS

Divide into ten parts the two upright sides of a brick drawn in perspective. Now divide the top into a hundred equal parts.

Draw a building in perspective. Show eight rows of windows on one side and six on the other.

Draw a checkerboard in two-point perspective. Show that the diagonals meet at a point on the eye level.

Draw the side elevation of a cabin with a door and two windows. Now draw the cabin in perspective. Show one window in the center of the end wall.

Draw a Grecian temple with columns.

STEP SIXTEEN

SHADE AND SHADOWS

SHADE

That part of the object that is not directly lighted is often spoken of as the *shaded side.*

The shade on the object is usually easier to determine on a drawing than is the shadow.

The simple rule for shade is to darken that part of the object that is facing away from the light source.

Shade becomes complex with irregularity of the object.

SHADOW

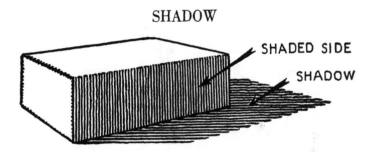

SHADED SIDE

SHADOW

A brick lying in the sun stops a portion of sunlight from reaching an area. The dark patch thus formed on the area is the *shadow* of the brick.

The shape of this shadow depends upon three things: the direction of the sun, the position of the brick, the shape of the area on which the shadow falls.

As the sun moves the shadow changes. The brick may be thought of in this instance as a sundial.

If the brick is moved the shadow is changed.

157

If the brick is placed on an uneven area, or if some object is placed in the way of the shadow, the shape of the shadow is changed.

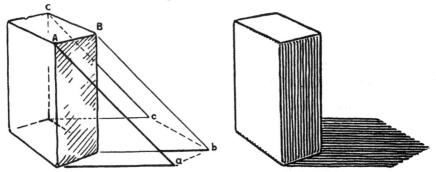

Stand the brick on end on a flat level surface.

Now let us assume that the sun is at our left. This position of the light source is usually assumed except in the case where the object that is being sketched is lighted otherwise.

It is now the time of the day when the length of a man's shadow is the same as his height.

Now let us take the shaded edge of the brick nearest to us.

The shadow of this edge extends out from the base a brick's length (to a).

The shadow of the farthest edge extends out the length of that edge (to c).

The shadow of the middle edge extends to b.

These points (a, b, and c) determine the length and shape of the shadow.

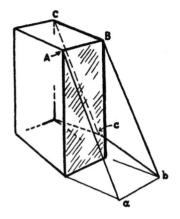 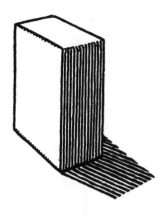

The sun moves higher in the sky and also around so that the shadow moves toward us.

The shadow, let us assume, is now approximately half the height of the brick.

Now, in order to determine this shadow, we use the same method as in finding the full-length shadow. We use half a brick-length now instead of a full brick-length. Notice how the shadow is shortened. Notice also that the place at *c* where the shadow changes direction is hidden by the brick.

PERSPECTIVE IN SHADOWS

We discover that shadows follow rules of perspective. The edge of the shadow *a* to *b* can be extended to meet the vanishing point of the edge of the brick *A* to *B*. This holds true because they are parallel. The same relationship applies to *b* to *c* and *B* to *C*. The remain-

ing two edges of the shadow are parallel and converge to their own vanishing point at the eye level.

Parallel lines cast parallel shadows on a flat surface.

CHANGING THE SHADOW SURFACE

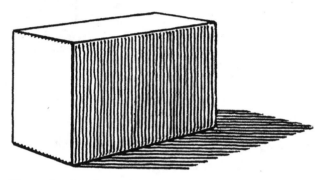

Place the brick on its side.

The shadow changes with the position of the brick.

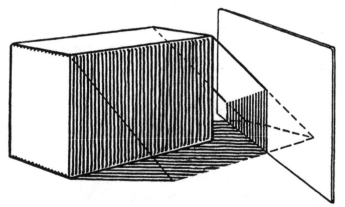

Place a piece of board upright across the corner of

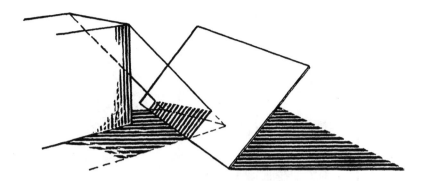

the shadow. The shadow becomes upright where it is cast on the board. Notice that the edge of the shadow turns where it touches the edge of the board. The direction of light from the corners of the brick determines where the shadow ends.

Tilt the board and watch the change in the shadow. Notice how this change can be located on the drawing. The shadow turns as the board is turned. The above sketch includes the shadow cast by the board.

Sunlight shining through an opening into a room obeys the same rules we use in locating shadows. The shape of the opening determines the shape of the sunlit area on the surface within the room. This is easily seen when light comes through a window making a patch of unobstructed sunlight on the floor; the entire window is reproduced there including the mullions. When the sunlight reaches the wall it behaves the same as when we placed the board upright across the shadow.

161

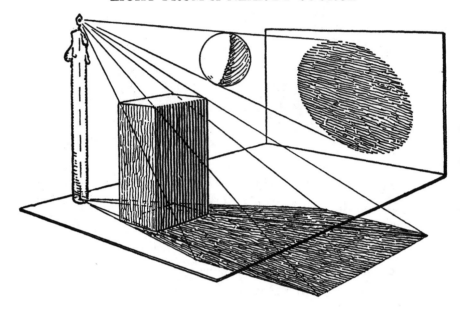

Here we have a brick standing on end, a ball suspended and a lighted candle near them.

Notice that the lines indicating the light from the candle cause the shadow of the brick to fan out, also that all four corners appear in the shadow.

The shadow of the ball on the wall is an ellipse and is much larger in area than the circle of the ball. This is due to the fanning out of the shadow.

The enlargement of a shadow due to a near-by source of light may produce the grotesque effects which are often utilized in stage lighting and in motion pictures.

162

THE SHADED SIDE

Notice the shaded side of the ball (page 162). It has a dark edge nearest the light. This is characteristic of curved surfaces.

The side of the object away from the light receives considerable reflected light from the surface where the shadow lies. The edge of the shade that is nearest the light is the farthest from this reflected light-source. The edge of the shaded portion therefore appears darker and this appearance is strengthened by the fact that the edge is in contrast with the lighted area adjoining it.

Reflected light on a shaded portion often produces what is termed a luminous shadow. The light and color from the reflecting object produce this effect.

VARIETY OF A SHADOW

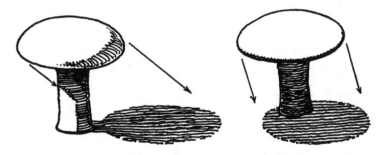

Objects other than bricks have their own peculiar shadows.

We have a mushroom with its shadow as it would appear in the early morning and near noon. If the sun were directly above, the shadow would be a circle instead of an ellipse. Note that the shadow of the stem is lost in the shadow of the overhanging top. This sketch could apply to such things as a beach umbrella or a doorknob.

THE SHADOW OF A CONE

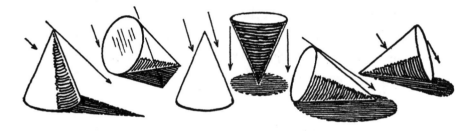

A cone is an example of a plain object that casts a variety of shadow shapes.

The cone resting on its base casts a pointed shadow.

When the light-source is above the cone, it has no visible shadow.

If the cone were standing upright on its apex with the light directly above, the shadow cast would be a circle. Tilt the cone and the shadow becomes elliptical.

When the cone is on its side the shadow may be an ellipse, a triangle, or a combination of the two.

Summary

Shadows are often so complex that it is difficult to solve the problem by mechanical methods. The few simple principles that have been given here will help to clear up a great number of difficulties.

Remember

A shadow changes with the direction of the light source, the moving of the object, and the change of the shape of the area on which the shadow is cast.

Shade on curved surfaces is usually darkest along the edge nearest the source of light.

A shadow fans out as the light source is brought closer.

Rays from sunlight are considered parallel.

Problems

Leave various objects unmoved in the sunlight. In the forenoon sketch them showing their shadows. Sketch them in the late afternoon.

Sketch the objects using a near-by source of light such as a candle.

Experiment with an empty ink bottle and find the different shapes of shadows it may cast.

Make a sketch showing sunlight on the floor of a room. The time is noon and the sunlight is coming through a window.

Make another sketch showing that the time of day is near sunset.

STEP SEVENTEEN

REFLECTIONS

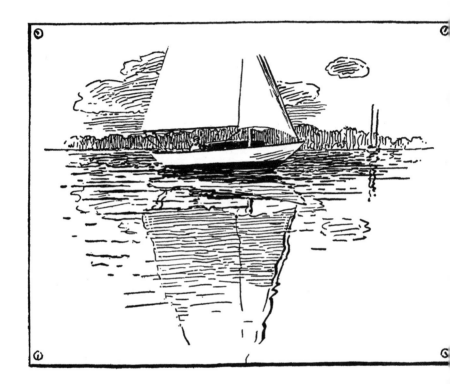

REFLECTIONS

The image of an object mirrored on a surface is a reflection.

An object lying on a mirror reflects itself upside down.

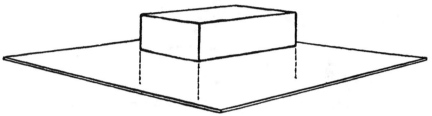

Sketch a brick lying on a mirror; extend the sides straight down the same distance as the height of the brick.

The ends of these lines are the upper corners of the brick reflected in the mirror.

Lines between these points form the reflections of the upper edges of the brick.

It can be seen that the reflection is upside down.

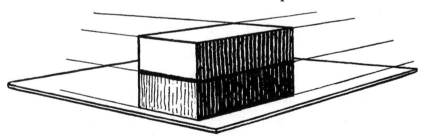

When the reflection is completed we find that it has the same vanishing points as the object itself.

Here is a piece of glass held flat between the palms of the hands.

If we draw the hands in this position the result will be the same as if the piece of transparent glass had become a mirror. The hand beneath is nothing less than the reflection of the hand above.

If the piece of glass remains in position and the hands are moved apart, our drawing still would look as if there were but one hand with its reflection in the mirror below.

We find that the reflection sinks below the surface as far as the object is raised above.

Often we see photographs of a mountain reflected in a lake. It is sometimes difficult to tell whether or not the photograph is right side up. Comparing this scene with the drawing above we see that the mountain itself is the upper hand, the lake is the piece of glass, and the

reflection is the under hand, palm up, pressing against the under surface of the glass. The reflection is *left-handed and upside down*. The nearer the eye-level is to the reflecting surface the closer is the resemblance of the reflection to its object counterpart.

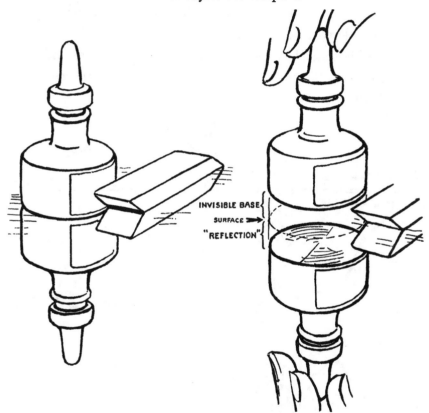

Use the same rule as applied to the hands when the object is an ink bottle or eraser or anything we wish to draw.

If the object is lifted any distance from the reflecting surface its upside-down reflection sinks an equal distance below the surface.

Notice that the reflection is "left-handed and upside-down."

The ink bottle that is held above the surface may be considered as sitting on an invisible stand. The invisible stand has also its invisible "reflection" extending from the surface down to the base of the reflected bottle.

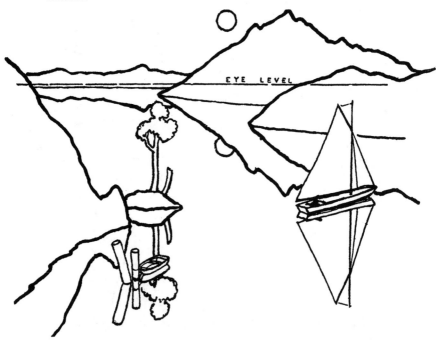

In drawing a lake with reflections consider a moun-

tain or a jutting point of land as an irregular shape like a hand, with the reflection like the other hand immediately underneath.

The moon and its reflection are equally distant from the horizon.

REMEMBER

Any object lying on a mirror surface is reflected left-handed and upside-down.

If the object is lifted above a reflecting surface its reflection sinks an equal distance below the surface.

If you stand in front of a mirror your reflection is as far back in "Looking-Glass Land" as you are from the mirror.

PROBLEMS

Place a small mirror flat on your desk. On the mirror surface place a drinking glass and a teaspoon beside it. Sketch these two objects. Place other small articles on the mirror and sketch them with their reflections.

Suspend an object an inch or so above the mirror. Sketch it with its reflection.

Make a drawing of a man sitting on a spile fishing. Show the reflection of the man and the piling.

Make a drawing of a swimmer about to dive from a diving board. Show him in mid-air. Show reflections.

Make a drawing of a leaning post surrounded by still water. Show its reflection.

Show the post leaning toward you. Show its reflection.

Show the post leaning away from you. Show its reflection.

173

STEP EIGHTEEN

UNUSUAL PERSPECTIVE

UP-AND-DOWN POINTS

EXAMPLES

UP-AND-DOWN POINTS

A room corner; looking up.

If you lie on your back, you will see that all up-and-down (perpendicular) lines in the room meet at a point on the ceiling directly above your head.

In the woods where the trees grow tall and straight they all radiate toward a point in the sky directly above your head as you lie on the grass looking up.

This means that you have turned your world part way around so that the perpendicular lines are now your horizontal lines.

Unusual pictures of skyscrapers and tall construction are obtained by this method. This can be done looking down as well as looking up.

Let us find out more about this vanishing point above us.

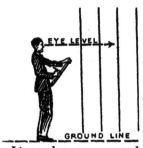 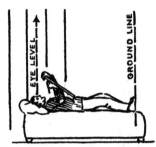

Lines that are up-and-down from the eye-level line.

The up-and-down lines now become parallel with the eye-level.

The diagram at the left shows a person standing while making a sketch. Notice that the ground line on which he is standing is horizontal. His eye-level is parallel with the ground line and is horizontal also. The up-and-down lines are perpendicular to the ground line and are perpendicular to the line of his eye-level.

Now let us suppose that the person continues to sketch but instead of standing erect he lies in a horizontal position so that his body is parallel with the ground line. The position is shown at the right.

He has changed the position of his world. The lines which formerly appeared up-and-down are now parallel with his new eye-level and ground line.

All parallel lines appear to recede to one vanishing point when we look in the direction of those lines. This holds true when we look along up-and-down parallels as the person is doing in the right-hand diagram. The vanishing point is directly above him. This principle holds true also when looking straight down.

178

PERSPECTIVE "LOOKING UP" AND "LOOKING DOWN"

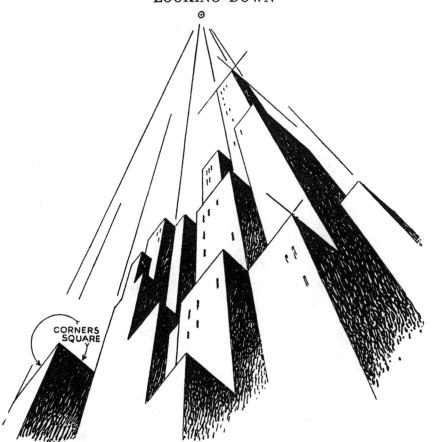

CORNERS
SQUARE

In this drawing we do not attempt to show the base
of the building; we can't see it, we are looking up.

The tops of all the buildings are made with square
corners the sides of which are parallel, having no van-
ishing points. This is not a hard and fast rule but

179

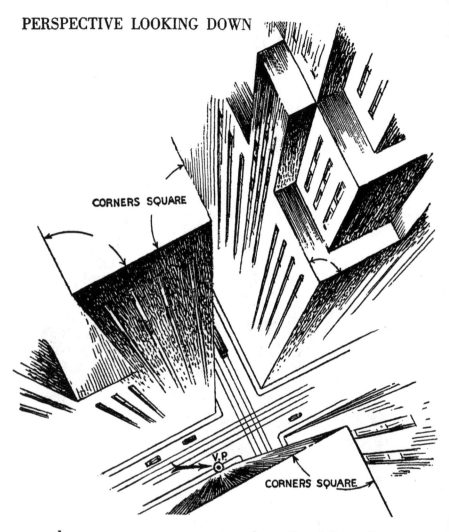

CORNERS SQUARE

CORNERS SQUARE

V.P.

the square corners are correct for a "straight up" or "straight down" effect. The explanation for this is given on the next page.

"Looking down" perspective is the same as the "looking up" kind. It is in reality one-point perspective. The vanishing point is directly below. This arrangement resembles our railroad-track drawing in which the upright telegraph poles and the ties of the track make square corners, that is, are perpendicular to each other. The lines of the building become these square corners in the drawing.

The effect is easier seen if the page is held cornerwise so that the lines forming a side of the square are up-and-down.

REMEMBER

When you lie on your back you are creating an imaginary eyelevel which is directly overhead. All perpendicular lines lead to the zenith, a point directly above your head.

You cannot see the base of a tree or building when you are looking straight up.

A view straight up or straight down can be sketched with one-point perspective.

PROBLEMS

Before you arise in the morning study your room from the standpoint of perspective looking up. Notice how all the up-and-down lines point toward the ceiling directly over your head. Make a sketch of the walls and ceiling near your bed as you see them.

Look out of the window and study the perspective looking down. Locate the place on the ground directly below you. Make a sketch of this scene looking down. A high window is best for this experiment.

You are looking down an elevator shaft from the sixth floor. Make a sketch of what you would see. Show the elevator cables and the doors at each floor.

You are on the sidewalk in front of a church watching some pigeons flying about the belfry. Make a sketch of what you see.

181

STEP NINETEEN

PERSPECTIVE DOWNHILL

PERSPECTIVE UPHILL

THE FALSE EYE-LEVEL

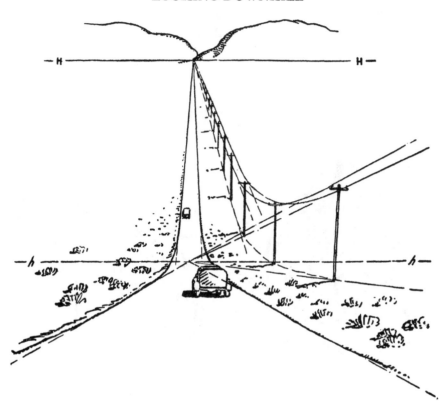

Here is the perspective drawing of a highway seen from the top of a hill.

The foreground view is downhill. This creates an imaginary horizon shown by the dotted line *h-h*.

In the distance we have the level highway with the normal horizon *H-H*.

This drawing is quite stiff and mechanical. It is

designed to illustrate a principle which, after one has
mastered it, can give a great amount of freedom. The
road, for instance, can wind in graceful curves and dis-
appear over low hummocks, appearing again at the
next rise.

LOOKING UPHILL

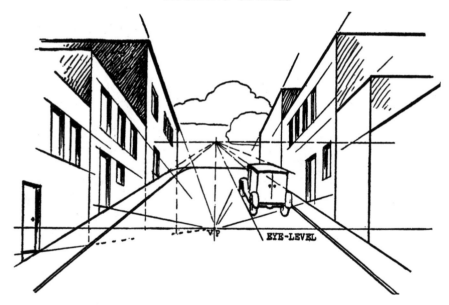

Here is an uphill street.

Notice that the street vanishes at an imaginary van-
ishing point directly above the eye-level point (VP).

The vehicle at the right has the same vanishing point
as that of the street because it is parallel with the di-
rection of the street. The buildings do not tilt uphill

like the street; they are built on level lines and the vanishing point lies on the normal horizon. This holds true in two-point as well as in one-point perspective.

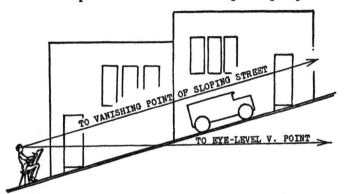

We have learned in normal perspective that we look along the level to find our vanishing points. When looking uphill we look for the vanishing points uphill also.

This diagram explains the two vanishing points. The artist has a normal eye-level and a false eye-level. The latter is created by the sloping street.

PROBLEM

An old churn is composed of a stand and a container. The container is a cube with the crankshaft passing diagonally through from corner to corner.

Now place the container in position on the stand and draw it from three different points of view.

187

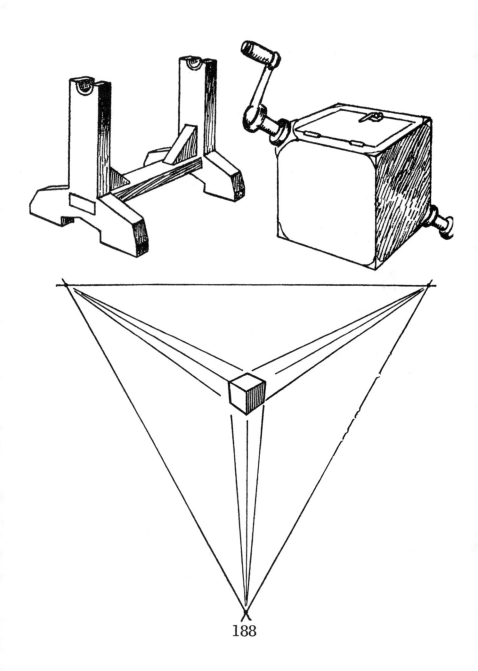

188

Suggestion:

The diagram shown beneath the churn and stand is a cube drawn so that, when the page is rotated, the cube is found to have three "eye-level" lines. An application of this principle may be used to solve the churn problem.

REMEMBER

When you look downhill or uphill you consider the slope as level, thus creating a false line of vision. The true eye-level, however, is always present in the drawing.

PROBLEMS

An alley is level for half its length. At this point the grade suddenly turns up to meet a street level. Make a drawing of this alley from each street.

You are standing in the center of a landing. The walk in front of you descends to another landing twenty stair-steps below. Make a drawing of the steps and walk as you see them from above.

You are standing in the road on a hilltop. The road winds down through a valley below. Make this sketch.

STEP TWENTY

MECHANICAL PERSPECTIVE

MECHANICAL PERSPECTIVE

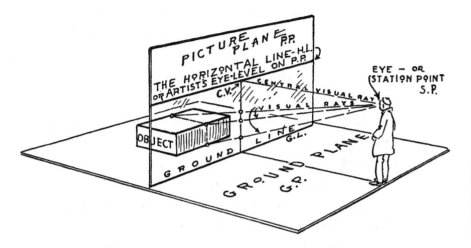

We have been learning about perspective as we would use it in sketching and freehand drawing. We will now learn something about the mechanical perspective that is used in the more exacting sciences of drawing. This method is based on plans, elevations, and exact measurements of the object to be drawn. The following brief explanation is only a step in an interesting science of which there is a great deal to learn.

We start with the *Picture Plane* as it is explained on page 28. This Picture Plane (called *P.P.* for convenience) stands upright like a transparent wall between the object and the artist. The object and the artist are both standing on a level plane called the

Ground Plane (called *G.P.* for convenience). The Picture Plane is perpendicular to the Ground Plane. The line where they meet is the Ground Line (*G.L.*).

The artist sees the object through the transparent Picture Plane. Note on the diagram where three points on the object appear on this surface.

Mechanical perspective furnishes a means of locating a sufficient number of these points on the Picture Plane so that the object can be correctly drawn.

We discover that the position of these points can be changed by the artist; by raising or lowering the eye-level and by moving toward or away from the Picture Plane. We also discover that the position of the points can be changed by moving the object.

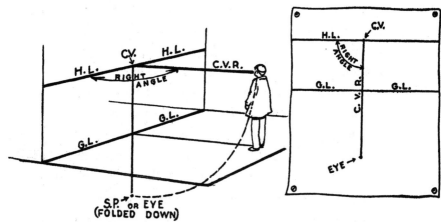

We determine the height of the artist's eyes from the Ground Plane, then we draw an eye-level line along

194

the Picture Plane. This is the *H.L.* or *Horizontal Line.*
Draw this familiar Eye-Level Line across a sheet of
drawing paper, with the parallel Ground Line below it.
The paper before us has now become the Picture Plane.

A line from the artist's eye perpendicular to *H.L.* is
called the *Central Visual Ray* (*C.V.R.*).

The point where this ray meets the *H.L.* is called the
Center of Vision (*C.V.*).

In order to show on our plan drawing the distance
between the artist and the Picture Plane (the *C.V.R.*)
we fold the Ground Plane down from the *G.L.* so that
it is flush with the Picture Plane. The line *C.V.R.* can
then be measured straight down from *C.V.* to Eye or
Station Point (*S.P.*) folded down.

We now have the diagram redrawn in the form of a
plan on our sheet of drawing paper showing the artist's
eye-height and his distance from the Picture Plane. We
are ready to begin drawing the object.

NOTE

It might be well to explain again that the term *Plan*
as used in this STEP means looking straight down upon
the object. No perspective is used in a plan.

An *Elevation* is a view of the side of an object with
no indicated perspective.

195

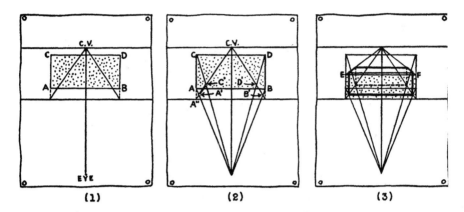

(1) (2) (3)

Place the object, a brick for example, in a position opposite the Picture Plane and resting on the Ground Plane. This arrangement is shown in the plan (1).

The corners of the brick are marked *A*, *B*, *C*, and *D*.

Extend lines *AC* and *BD* down to the Ground Line. This gives the true measurement of the line *AB* on the surface of the Picture Plane.

From these two points (where *AC* and *BD* meet the Ground Line) draw lines to the vanishing point *C.V.* This shows the two sides of the plan *AC* and *BD* in perspective. On these lines we must locate the plan of the brick in perspective (*A'B'C'D'*).

Point *C.V.* is the vanishing point because it is on the eye-level and also on the Central Visual Ray which is a line from the artist's eye parallel to the receding sides of the brick. The lines of the brick perpendicular to the Picture Plane recede to this vanishing point.

196

Returning to the plan (2); draw lines from A and C to the artist's eye. These represent the Visual Rays as shown on the diagram on page 193. Where these visual rays cross the receding line (A'' to $C.V.$) we have two points A' and C'. The line $A'C'$ is AC in perspective. The same applies to $B'D'$.

Now draw the elevation of the brick as it rests on the Ground Line (3). Lines from the upper corners E and F can be extended to the vanishing point. This gives the top of the brick in perspective. With the top and the bottom of the brick located we can now determine the sides by drawing lines from A' B' C' and D' perpendicular to the Ground Line.

The brick does not necessarily have to be centered on the line $C.V.R.$ We can solve the problem by the above method whether the brick is placed to the right or to the left of line $C.V.R.$ providing of course the brick remains parallel with the Ground Line.

Let us try it now in two-point perspective.

So far we have considered a situation in which the face of the brick is parallel to the Picture Plane. Now we turn the brick at an angle and create the same situation as shown on page 50 (the left-hand diagram).

One way of solving angular or two-point perspective is a method used by architects. This method is the combining of the plan, the elevation, and the diagram from page 194.

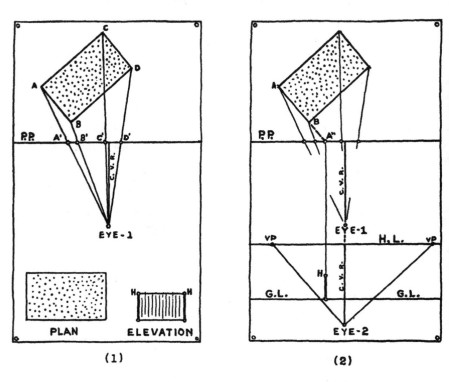

(1) (2)

Place the brick back from the Picture Plane (Diagram 1) and show the visual rays from the *EYE-1* to the corners of the plan *ABCD*. These rays pass through the Picture Plane at *A'B'C'D'*.

Now arrange this as shown in diagram (2). The new Horizontal Line, Ground Line, and Eye position are placed a convenient distance below. *EYE-2* is the same distance from *H.L.* as *EYE-1* is from *P.P.* The *C.V.R.*

Line of the two diagrams becomes a continuous straight line.

We now locate the two vanishing points on line *H.L.*

Lines from *EYE-2* drawn parallel to the two adjacent sides of the brick meet the *H.L.* at two points. This method is explained on page 50.

We have the plan of the brick; now it is necessary to show its height.

Extend *AB* until it meets *P.P.* at *A″*. From *A″* draw a line parallel to *C.V.R.* and extend it to the Ground Line. We can now measure the true height of the brick from the Ground Line to *H* on this line.

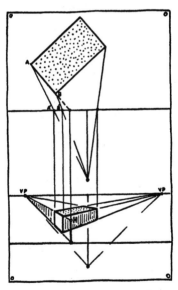

We now have the height of the brick measured on the

199

elevation of the Picture Plane. If we carry this upright line to the vanishing point on the left we have a wall in perspective the height of the brick.

The end of the brick forms part of this wall. Now to locate it.

We know that the artist sees line AB as line $A'B'$ on the Picture Plane. We now project $A'B'$ down to the wall we have drawn in perspective. In this manner we cut off the part of the wall that is the end of the brick.

The diagram shows how the other faces of the brick are located.

When we have learned to draw a brick in mechanical perspective we have gained knowledge by which we can draw all geometric shapes: a chest of drawers, a house with gables, a temple with colonnades and domes, a cathedral with towers and buttresses.

The few rules given here are a bare suggestion of mechanical perspective. For the student who wishes to learn more of this science, there are excellent books of advanced treatment. The knowledge gained adds greatly to the artist's power of observation and interpretation.

SHORT CUTS

Many short cuts have been developed from mechanical perspective. Here we have one used by commercial artists in determining the spacing of windows of a building drawn in perspective.

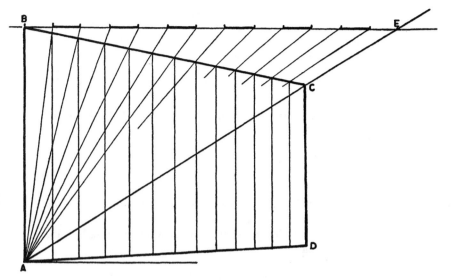

The side of a building when drawn in perspective is shown as *ABCD* in the diagram.

We wish to divide this space in perpendicular rows of windows; six in this case. Now how to space them.

First we draw a horizontal line through *B* (the top and near corner of the building).

Next we draw a diagonal line from *A* through *C*. Extend it until it crosses the horizontal line at *E*.

Now we divide the line *B* to *E* into the spacings of the window plan. There are six windows in this instance.

From these points we draw lines down to *A*. These lines pass through the top line of the building. The points where they intersect locates the perpendicular lines of the windows.

201

Remember

Mechanical perspective is based on three principal units: the artist observer, the object, the ground line and picture plane arrangement.

Visual rays are imaginary lines from the artist's eye to a point on the object.

Mechanical perspective should enrich and not hinder the artist's freehand drawing.

Problems

Draw a brick in various positions using mechanical perspective. Draw a house in the same manner.

Draw a square building with ten rows of windows on each of the sides toward you.

Summary

Study the railroad track, it will furnish the fundamentals of perspective.

Learn to draw a brick, you will then have a working knowledge of perspective.

Learn all you can about the "Big Three" of perspective: the Eye-Level, Vanishing Point A, and Vanishing Point B.

Do not let the mechanics of perspective cramp your freehand drawing.

Use your knowledge of perspective to insure accuracy in your drawing and to check for error.

Learn all you can about perspective. The knowledge gained will give you confidence in your drawing and thus allow more freedom.

Sketch an object freely and naturally; try to avoid laying out a cold mechanical setting and forcing the object into it. Perspective can easily be overdone.

Remember the value of intersecting diagonals (crosslines) to find a center.

Always place the two vanishing points far apart, thus avoiding violent perspective.

Do not concern yourself about the technical placing of vanishing points in freehand perspective—their position is approximate.

Study any good technical book for the mechanical placing of vanishing points. This knowledge is very useful for mechanical renderings.

Remember the manner in which one vanishing point moves in relationship with the other. This is important.

Draw a whole city by drawing the arrangement of bricks.

Think of bricks and cylinders as the basis for most of the things we sketch in perspective.

Learn to draw a cylinder and your knowledge of drawing has been greatly broadened.

The inside of a room is the inside of a box. Learn how to draw a box.

Try drawing a checkerboard in two-point perspective. It is a good test for correct drawing.

If an object is difficult to draw because of its irregular shape, consider it as fitted inside a box; then draw the box in perspective.

Don't attempt to include too much in a perspective drawing, the eye includes only a small area.

Consider upright or perpendicular lines as drawn parallel, having no vanishing point considered.

Think of the reflection of an object as left-handed and upside down.

Use the same vanishing points for the reflection as for the object. This is true when the object is level with the reflecting surface.

Don't confuse a reflection and a shadow, they are not the same.

A CATALOG OF SELECTED
DOVER BOOKS
IN ALL FIELDS OF INTEREST

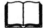

A CATALOG OF SELECTED DOVER
BOOKS IN ALL FIELDS OF INTEREST

100 BEST-LOVED POEMS, Edited by Philip Smith. "The Passionate Shepherd to His Love," "Shall I compare thee to a summer's day?" "Death, be not proud," "The Raven," "The Road Not Taken," plus works by Blake, Wordsworth, Byron, Shelley, Keats, many others. 96pp. 5⁵⁄₁₆ x 8¼. 0-486-28553-7

100 SMALL HOUSES OF THE THIRTIES, Brown-Blodgett Company. Exterior photographs and floor plans for 100 charming structures. Illustrations of models accompanied by descriptions of interiors, color schemes, closet space, and other amenities. 200 illustrations. 112pp. 8⅜ x 11. 0-486-44131-8

1000 TURN-OF-THE-CENTURY HOUSES: With Illustrations and Floor Plans, Herbert C. Chivers. Reproduced from a rare edition, this showcase of homes ranges from cottages and bungalows to sprawling mansions. Each house is meticulously illustrated and accompanied by complete floor plans. 256pp. 9⅜ x 12¼.
0-486-45596-3

101 GREAT AMERICAN POEMS, Edited by The American Poetry & Literacy Project. Rich treasury of verse from the 19th and 20th centuries includes works by Edgar Allan Poe, Robert Frost, Walt Whitman, Langston Hughes, Emily Dickinson, T. S. Eliot, other notables. 96pp. 5⁵⁄₁₆ x 8¼. 0-486-40158-8

101 GREAT SAMURAI PRINTS, Utagawa Kuniyoshi. Kuniyoshi was a master of the warrior woodblock print — and these 18th-century illustrations represent the pinnacle of his craft. Full-color portraits of renowned Japanese samurais pulse with movement, passion, and remarkably fine detail. 112pp. 8⅜ x 11. 0-486-46523-3

ABC OF BALLET, Janet Grosser. Clearly worded, abundantly illustrated little guide defines basic ballet-related terms: arabesque, battement, pas de chat, relevé, sissonne, many others. Pronunciation guide included. Excellent primer. 48pp. 4⁵⁄₁₆ x 5¾.
0-486-40871-X

ACCESSORIES OF DRESS: An Illustrated Encyclopedia, Katherine Lester and Bess Viola Oerke. Illustrations of hats, veils, wigs, cravats, shawls, shoes, gloves, and other accessories enhance an engaging commentary that reveals the humor and charm of the many-sided story of accessorized apparel. 644 figures and 59 plates. 608pp. 6 ⅛ x 9¼.
0-486-43378-1

ADVENTURES OF HUCKLEBERRY FINN, Mark Twain. Join Huck and Jim as their boyhood adventures along the Mississippi River lead them into a world of excitement, danger, and self-discovery. Humorous narrative, lyrical descriptions of the Mississippi valley, and memorable characters. 224pp. 5⁵⁄₁₆ x 8¼. 0-486-28061-6

ALICE STARMORE'S BOOK OF FAIR ISLE KNITTING, Alice Starmore. A noted designer from the region of Scotland's Fair Isle explores the history and techniques of this distinctive, stranded-color knitting style and provides copious illustrated instructions for 14 original knitwear designs. 208pp. 8⅜ x 10⅞. 0-486-47218-3

ALICE'S ADVENTURES IN WONDERLAND, Lewis Carroll. Beloved classic about a little girl lost in a topsy-turvy land and her encounters with the White Rabbit, March Hare, Mad Hatter, Cheshire Cat, and other delightfully improbable characters. 42 illustrations by Sir John Tenniel. 96pp. 5⅜₆ x 8¼. 0-486-27543-4

AMERICA'S LIGHTHOUSES: An Illustrated History, Francis Ross Holland. Profusely illustrated fact-filled survey of American lighthouses since 1716. Over 200 stations — East, Gulf, and West coasts, Great Lakes, Hawaii, Alaska, Puerto Rico, the Virgin Islands, and the Mississippi and St. Lawrence Rivers. 240pp. 8 x 10¾.
 0-486-25576-X

AN ENCYCLOPEDIA OF THE VIOLIN, Alberto Bachmann. Translated by Frederick H. Martens. Introduction by Eugene Ysaye. First published in 1925, this renowned reference remains unsurpassed as a source of essential information, from construction and evolution to repertoire and technique. Includes a glossary and 73 illustrations. 496pp. 6⅛ x 9¼. 0-486-46618-3

ANIMALS: 1,419 Copyright-Free Illustrations of Mammals, Birds, Fish, Insects, etc., Selected by Jim Harter. Selected for its visual impact and ease of use, this outstanding collection of wood engravings presents over 1,000 species of animals in extremely lifelike poses. Includes mammals, birds, reptiles, amphibians, fish, insects, and other invertebrates. 284pp. 9 x 12. 0-486-23766-4

THE ANNALS, Tacitus. Translated by Alfred John Church and William Jackson Brodribb. This vital chronicle of Imperial Rome, written by the era's great historian, spans A.D. 14-68 and paints incisive psychological portraits of major figures, from Tiberius to Nero. 416pp. 5⅜₆ x 8¼. 0-486-45236-0

ANTIGONE, Sophocles. Filled with passionate speeches and sensitive probing of moral and philosophical issues, this powerful and often-performed Greek drama reveals the grim fate that befalls the children of Oedipus. Footnotes. 64pp. 5⅜₆ x 8 ¼. 0-486-27804-2

ART DECO DECORATIVE PATTERNS IN FULL COLOR, Christian Stoll. Reprinted from a rare 1910 portfolio, 160 sensuous and exotic images depict a breathtaking array of florals, geometrics, and abstracts — all elegant in their stark simplicity. 64pp. 8⅜ x 11. 0-486-44862-2

THE ARTHUR RACKHAM TREASURY: 86 Full-Color Illustrations, Arthur Rackham. Selected and Edited by Jeff A. Menges. A stunning treasury of 86 full-page plates span the famed English artist's career, from *Rip Van Winkle* (1905) to masterworks such as *Undine, A Midsummer Night's Dream,* and *Wind in the Willows* (1939). 96pp. 8⅜ x 11.
 0-486-44685-9

THE AUTHENTIC GILBERT & SULLIVAN SONGBOOK, W. S. Gilbert and A. S. Sullivan. The most comprehensive collection available, this songbook includes selections from every one of Gilbert and Sullivan's light operas. Ninety-two numbers are presented uncut and unedited, and in their original keys. 410pp. 9 x 12.
 0-486-23482-7

THE AWAKENING, Kate Chopin. First published in 1899, this controversial novel of a New Orleans wife's search for love outside a stifling marriage shocked readers. Today, it remains a first-rate narrative with superb characterization. New introductory Note. 128pp. 5⅜₆ x 8¼. 0-486-27786-0

BASIC DRAWING, Louis Priscilla. Beginning with perspective, this commonsense manual progresses to the figure in movement, light and shade, anatomy, drapery, composition, trees and landscape, and outdoor sketching. Black-and-white illustrations throughout. 128pp. 8⅜ x 11. 0-486-45815-6

Browse over 9,000 books at www.doverpublications.com